# PARANORMAL SCOTLAND

GILLY PICKUP

AMBERLEY

First published 2020

Amberley Publishing
The Hill, Stroud
Gloucestershire, GL5 4EP

www.amberley-books.com

British Library Cataloguing in Publication Data.
A catalogue record for this book is available from the British Library.

ISBN 978 1 4456 9976 9 (print)
ISBN 978 1 4456 9977 6 (ebook)

Typesetting by SJmagic DESIGN SERVICES, India.
Printed in Great Britain.

# Contents

# Introduction

*From ghoulies and ghosties and long leggedy beasties and things that go bump in the night, Good Lord deliver us.* (Traditional Scottish prayer)

Assorted strange phenomena abound in the land that was once known as Dalriada. Indeed, Scotland has it all, witches, wizards, fairies, sea monsters, yeti-type creatures, UFOs and a plethora of female spirits called glastigs and caoineags who appear in various forms. Besides that, there is a bewitching range of grey ladies, white ladies and green ladies, naughty poltergeists, unwanted love children, kilted bagpipers, bloodstained clansmen and abstract, floating columns of light. Of course, your 'common' everyday 'spook' makes plenty of appearances as well as ethereal drummers, phantom vehicles and spectral dogs and horses … yes, Scotland is simply packed with ghosts.

Many people expect phantoms to reside among the ruins of draughty old castles and of course, they do, masses of them. However, even though Scotland's apparitions may lack a physical body, they certainly don't lack imagination. Dalriada's ghosts haunt

There's something strange in the neighbourhood …. who're you gonna call? (© Gilly Pickup)

battlefields, mountains, roads, barracks, beaches, railway lines, aerodromes, theatres, houses, caves, standing stones and churches.

Maybe this surplus of spooky goings-on is triggered by the country's long and bloody history, or it could be down to the hauntingly bleak moorlands, craggy mountains and ancient Caledonian forests. Whatever the reason, Scotland is rich in blood-chilling tales and has more ghosts, hauntings and supernatural happenings than any other land on earth.

This book takes a look at just some of the many weird goings-on around Scotland, my homeland. After all, doesn't everyone love a good ghost story? It doesn't matter whether or not people actually believe in ghouls, ghosts and things that go bump in the night. Even the more cynically minded will admit to just a wisp of worry about the supernatural and there can be few among us who would look forward to meeting a ghost.

Now all you have to do is sit down, make yourself comfortable and savour these nerve-jangling tales. Make sure you've locked your windows and doors first though.

Look – just over there – is that something moving? What is that you hear – it sounds like rustling and – sshhh – are those disembodied voices? Take heed because it is as well to remember the dead in Scotland far outnumber the living ...

*Gloweran round wi' anxious care, lest bogles catch me unaware ...* (Anon)

**A Ghostly Snippet:** Scotland is one of the world's most haunted countries.

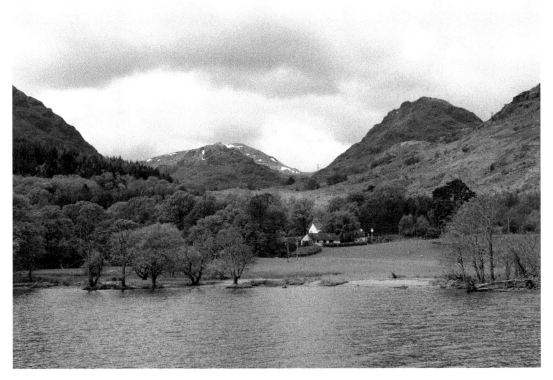

Scotland – one of the world's most haunted countries. (© Gilly Pickup)

# Castles and Grand Structures

This is the longest chapter in *Paranormal Scotland* because this beautiful country is awash with castles, palaces and tower houses – around 3,000 or so, all brimful of history. Some are grand structures while others are now in ruins and all have seen plenty of high drama. If walls could speak, they would certainly have many a story to tell and of course, considering their history, it is not surprising that many of them harbour a ghost – or two – or many more. I don't have enough space to include all of these palatial dwellings that contain spooks, so if I haven't included your favourite, I apologise. For those who like figures to keep things in context, around 600 are now used as private homes or hotels while 460 or so are open to the public, though some only for a couple of weeks each year. Do go and see some of them; I am sure you will enjoy your experience. I wonder, when you visit though, will the undead rattle their chains for you?

## Glamis Castle, Angus

This impressive fairy-tale castle with towers galore and witch-hat turrets was the birthplace and childhood home of Elizabeth Bowes-Lyon, youngest daughter of the 14th Earl. She became HRH Queen Elizabeth, mother of the present Queen. Her second daughter, Princess Margaret, was born here. A royal residence since 1372, this is a particularly haunted castle. For starters, the phantom of Earl Beardie plays cards non-stop with the Devil in a secret room, while the ghost of Lady Janet Douglas, widow of the Earl of Glamis and who was burned at the stake as a witch in 1537, has been seen in the family chapel.

When she was around fourteen years old, Lady Elizabeth Bowes-Lyon helped nurse soldiers from the First World War. They were convalescing in the castle, part of which became an auxiliary hospital for military personnel. Visitors can see the billiard room, originally a library where a photo shows a young Lady Elizabeth seated at the nineteenth-century Erard baby grand piano, one of the room's main features. The room, which also has over 2,000 books on display, is where recuperating soldiers would come to play snooker and there are still some cigarette marks on a table from when the men laid their cigarettes down while they played.

With its splendid tapestries and weaponry, the castle also has links to Shakespeare's chilling tragedy *Macbeth*. He begins the play as Thane of Glamis before murdering his way to power, killing King Duncan while he is asleep in bed. While there is just the vaguest chance that Shakespeare visited Glamis, Macbeth actually killed Duncan in battle near Elgin long before Glamis Castle existed. However, to keep the link alive,

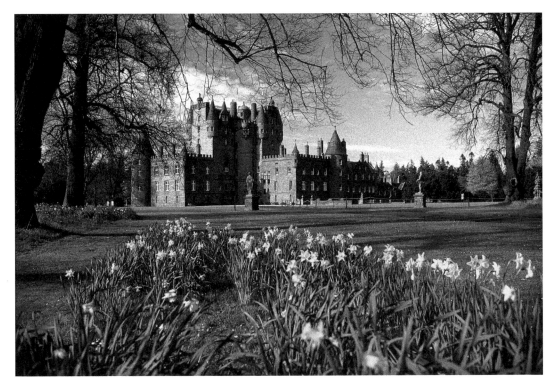

Glamis Castle, ghostly royal residence. (© Paul Tomkins/Visit Scotland/Scottish Viewpoint)

one of the oldest rooms in the castle is known as Duncan's Hall. Just as Macbeth was overcome by visions of the ghost of Banquo, so Glamis is said to be haunted by many ghosts, one of whom, a woman with no tongue, has been seen in the grounds and occasionally spotted looking out of a barred window, gesturing at her terrible injuries.

Another spectre, believed to be the ghost of Janet Douglas, Lady Glamis, haunts the family chapel in the castle. The chapel seats forty-six people and to this day, one seat is kept empty for the Grey Lady. No mortal is allowed to sit in it. She was burned at the stake as a witch in 1537 on Castle Hill, Edinburgh, on charges of plotting to poison the king. It was more than likely the charges were fabricated for political motives because hanging onto power and property in Scotland in those days depended a lot on backing the right factions in conflict and above all else, that you stayed on good terms with the monarch.

Janet's trouble began when her brother Archibald Douglas, 6th Earl of Angus, kidnapped his stepson James V when he was a child. When the said James gained power in 1528, he decided to take his revenge on the whole of his stepfather's family including Archibald's sister, the aforementioned Janet, widow of John Lyon, 6th Lord Glamis. Hence the witchcraft accusation. James seized Glamis Castle for the Crown and regularly stayed there. Worse still, although Janet's son John, 7th Lord Glamis, was only a child, he was also condemned to death by James V. He was only released and the (ransacked) castle returned to him when James died in Falkland Palace in 1542.

It's not only Janet's ghost that wafts through the draughty corridors. Just as scary is the ghost of a young black boy, a badly treated servant who has been hanging around for over 200 years. He is reputed to haunt a seat by the door of the Queen's bedroom.

A door at Glamis Castle which opens
and closes by itself even when locked.
(© Gilly Pickup)

Yet another phantom is that of the deformed monster of Glamis who when alive, spent his days locked up away from prying eyes in a secret chamber.

There is also poltergeist activity in the castle: a heavy door opens and closes by itself even when carefully locked. This was experienced a few years ago by a film crew. Probably the most terrifying of all Glamis Castle's ghosts though is Earl Beardie, the 4th Earl of Crawford, who stayed as a guest at the castle. One night after a heavy drinking session he wanted to play cards. However, being Sunday, no one would play – no cards on the Sabbath. Beardie was annoyed and said, please yourselves, I'll play with the Devil himself if I have to. Just then, so the story goes – rather a coincidence it has to be said – a stranger arrived at the castle door asking Lord Beardie to play cards with him. Later servants heard shouting coming from the room. One peeped through the keyhole and the Earl burst from the room, angry with the servant for spying on him. When he returned to the room the stranger had disappeared and taken the Earl's soul, and so it is said Beardie has to play cards in that room for eternity. Now the eerie sounds of rattling dice, swearing and shouting can still be heard.

## Hermitage Castle, Hawick, Roxburghshire

This formidable-looking, grey stone fortress in embattled border country was built in the thirteenth century and has seen no end of conflicts between Scotland and England in days gone by. In 1342 Sir Alexander Ramsay was imprisoned here by Sir William Douglas and starved to death. His ghost is one who haunts the castle. Lord William

Eildon Hills, where
Lord Soulis studied
the black arts.
(© L. Moyse)

de Soulis lived here too – known as Bad Lord Soulis because, well he wasn't very nice to a lot of people. He studied black magic in the Eildon Hills under renowned warlock Michael Scott (see the chapter 'Churches, Abbeys and a Cathedral' to read more about him) and – so they say – offered human sacrifices to Satan in Hermitage Castle. Eventually though the locals had had enough of their evil overlord – you can't blame them – and they sent a petition to King Robert I in the hope of getting rid of him. The King replied, telling his subjects to hang him, boil him or do whatever they wanted with him. No sooner said than the locals sought out Soulis and dragged him to an ancient stone circle where they threw him into a cauldron of molten lead. Not only does he return to haunt the castle; there are tales of a sealed room in the keep where his spectre likes to hang out with demons.

## Culross Palace, Dunfermline

Built by Sir George Bruce around 1600 and he still comes back from time to time to check everything is as it should be. On a guided tour there are scary elements. You will go into a stone-vaulted strongroom where you may interrupt him counting his money. Although he smiles to children, he wards off adults who dare to get too close to his fortune. You could also see a young, prettily dressed ghost, that of Mary Erskine, carrying a bouquet of lavender as she admires the garden. Her family bought the palace in the early eighteenth century.

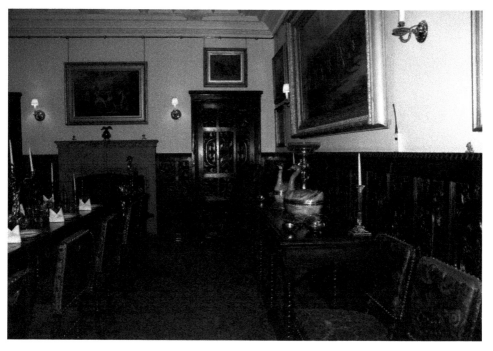

Dining room in Culross Castle where Sir George entertained. (© Gilly Pickup)

## Culzean Castle, Ayrshire

Perched high on the Ayrshire cliffs, this Robert Adam masterpiece is shrouded in tales of dastardly deeds and evil spirits. For starters there's the 4th Earl of Cassilis, who in 1570 captured the abbot of Crossraguel Abbey and proceeded to burn him alive until he agreed to sign over his lands. There's the uber wicked Sir Archibald too, a man so evil that the Devil himself was his best friend. Visitors have reported seeing a strange and ghostly mist which swirls up the grand staircase, while the spectre of a piper can be heard playing his pipes in the grounds on stormy nights as the waves pound the cliff face below.

## Edinburgh Castle

Scotland's number one visitor attraction is perched on an extinct volcano at the top of the Royal Mile. Dominating the skyline, this powerful national symbol of Scotland has seen many changes throughout the centuries and today is a mix of military barracks, palace, fortress, war memorial and World Heritage Site. It is also home to a plethora of ghostly beings. Visitors report seeing apparitions, feeling unwelcome presences and experiencing sudden temperature changes in and around the structure.

Rich in history, the castle is home to the ancient Stone of Destiny on which Scottish monarchs were crowned. It is kept safe in Edinburgh Castle Crown Room and the Scottish Crown Jewels, the 'Honours of Scotland', are there too. These are the oldest Crown Jewels in the British Isles, first used in the coronation of Mary, Queen of Scots in 1543.

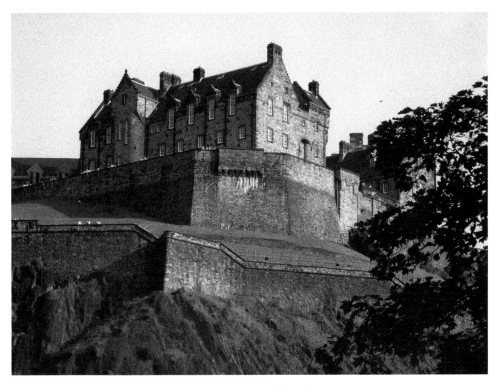

Edinburgh Castle, home to a gaggle of ghosts. (© Gilly Pickup)

The oldest part of the castle is St Margaret's Chapel built in the 1100s to commemorate Margaret, King David's mother, who died here in 1093. An example of Romanesque architecture, this category A listed building was used by the royals as a private place of prayer up until the sixteenth century when it became a gunpowder store before being restored as a chapel in 1845. Due to the political situation at the time, the chapel was for many months the resting place of Mary of Guise, Regent of Scotland, who wanted Scotland to be Catholic and independent of England. Mary, mother to Mary, Queen of Scots, died on 11 June 1560. On 6 July, the French, Scots and English signed the treaty of Edinburgh agreeing that foreign soldiers, French and English alike, would withdraw from Scotland and in August the Scottish parliament passed legislation making the country officially Protestant. Not until the following year was permission given for Mary of Guise's burial and in March 1561 she was secretly carried from the castle at the dead of night and shipped to France. Although her remains rest in Reims, her ghost still haunts Edinburgh Castle.

The castle vaults below the Great Hall have had many uses, not least as a prison. Their busiest period was during the War of American Independence between 1775 and 1783 and again during the wars with Revolutionary and Napoleonic France from 1793 to 1815. Among the prisoners was a five-year-old drummer boy taken at Trafalgar. Others have allegedly heard the sound of drums around Edinburgh Castle, with a few visitors even claiming they caught a glimpse of a headless drummer boy. Legend has it that whenever the drummer boy's ghost is spotted, the castle is about to come under attack – he was first seen in 1650, shortly before Oliver Cromwell attacked Edinburgh Castle.

In 1720 the vaults held twenty-one pirates whose ship was found full of Portuguese and French gold. They were found guilty and hanged below the high-water mark at Leith.

Prior to 1753 when the castle esplanade became a parade ground, it had a far more sombre use. At that time the open ground was an execution site and those accused of witchcraft or other dire deeds were burned at the stake. Around 300 alleged witches were imprisoned and tortured before being executed on Castlehill. One of the most famous of these unfortunates was Lady Janet Douglas of Glamis, accused of witchcraft and conspiring to kill King James V (see section on Glamis Castle).

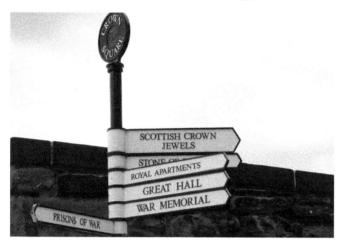

*Left*: Signpost at Edinburgh Castle. (© Mike Pickup)

*Below*: Edinburgh Castle by night. (© Gilly Pickup)

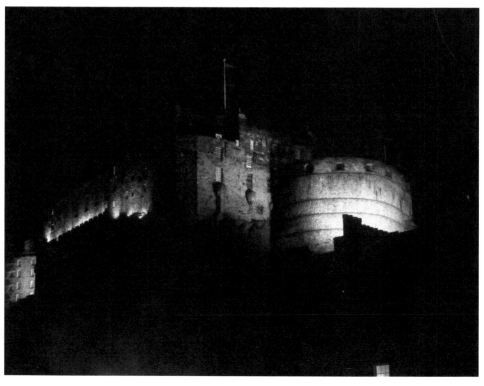

Her servants were tortured into confessing her guilt and in 1537 she was burned alive at the stake. She is often to be seen wandering round the castle weeping.

One of the most famous ghost stories here though concerns a bagpiper who disappeared. Hundreds of years ago secret tunnels were found under the castle. These led towards Holyrood House at the end of the Royal Mile. As the tunnel opening was narrow and small, a little boy with bagpipes was sent down to investigate. He played the pipes in the tunnel so that those above knew where he was. The pipes stopped abruptly below the Tron Kirk and, although people went down to try and find him, he was never seen again. After that the tunnel was blocked up but occasionally the faint, ghostly sound of bagpipes can still be heard.

Paranormal investigators regularly hold seances in the castle with thermal imagers, geomagnetic sensors and temperature probes used to record conditions in each room tested.

In all cases, most of the participants report unexplained phenomena. The highest number of paranormal experiences are recorded in the vaults, with sudden drops in temperature, feelings of being watched, burning sensations, and clothes being tugged.

# Dunrobin Castle, Golspie, Sutherland

Two ghosts call this castle home. In life one of them was a chambermaid who, it was chronicled, fell from the nursery window. Did she though, or was she pushed? Some think the latter is more likely. She was being chased by the Earl of Dunrobin at the time and he wanted her out of the way so that she couldn't pass on any gossip ...

Further down the line, in the late 1960s, the castle was used as a school and one day the headmaster saw a man on the landing. As he approached to ask what he was doing there, the figure just dissolved into a wisp of smoke and disappeared.

Dunrobin Castle, home to phantoms. (© VisitScotland and Paul Tomkins)

# Cawdor Castle, Nairn

North-east of Inverness, near Culloden's bloody battlefield, is this home of the Earl of Cawdor and a Campbell stronghold since 1511. The castle is well known for its unnatural changes in temperature and the fact that objects have the habit of simply disappearing. Worse still, how would you feel when visiting a castle on a sunny day and bumping into a young woman dressed in a lovely blue velvet dress – but with no hands? Yes, you might very well be spooked but this is exactly what has happened to some visitors to Cawdor Castle. Research shows that this terribly unfortunate girl was the Earl of Cawdor's daughter who lived in the late 1800s and who had a relationship with a young man from a family that the Earl disapproved of – it happens. If they hadn't flaunted their love though, the Earl may not have discovered her with her lover in their secret place. When he did, he was incensed, brimming over with rage. How dare she! When she saw her father, the girl ran off to try to escape his wrath. He chased her through the castle until she reached a dead end. What to do now? There was nothing else for it but to climb out of a window and try to reach the ground far below, but while her hands were still clinging to the windowsill, her father drew his sword and cut them off. How awful!

Cawdor Castle also has links to Shakespeare's *Macbeth*, where the title character is proclaimed Thane of Cawdor. Anyone who knows the play will know that he was cursed by a gaggle of witches, angry that Shakespeare dared to use one of their spells at the beginning.

Lands around Cawdor Castle. (© Gilly Pickup)

# Stirling Castle, Stirlingshire

Swarming in ghostly tales, this proud castle has more than its fair share of ghosts. It also has what other Scottish castles don't have and that's its own tour guide ghoul. This phantom appears in full Highland regalia complete with dirk and sporran. If you see him, don't freak out when he turns round and vanishes before your eyes! He was supposedly captured on camera in 1935 by an architect surveying the castle, though it is not clear whether or not the image is fake.

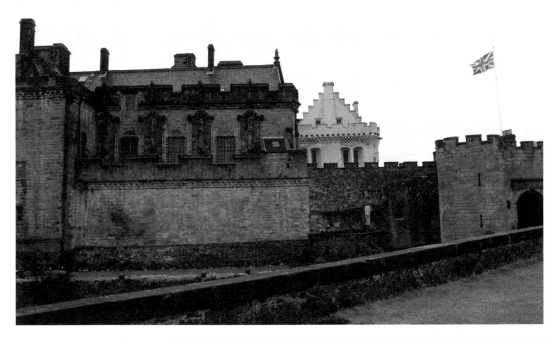

*Above*: You might see more than one ghost at Stirling Castle. (© Gilly Pickup)

*Right*: Glorious tapestries at Stirling Castle. (© Gilly Pickup)

Inside Stirling Castle – the James I Bible. (© Gilly Pickup)

Mary, Queen of Scots lived here and one of her serving girls haunts the rooms in which she looked after her mistress. Known as the Green Lady – yes, another one – legend tells this girl saved Mary's life when fire threatened to engulf the Queen's apartments. She herself perished. Sometimes she glides along a corridor before melting into the walls.

While many castles offer Grey, White and Green Ladies, it's not often you come across a Pink Lady. This pretty girl was due to be married to a knight who starved to death inside Stirling Castle while under siege by the English in 1304 during the Wars of Independence. She died too, not from starvation but from a broken heart. Her spirit still roams the castle, bringing with it the faintest scent of rose blossom.

## Toward Castle, Dunoon, Argyll and Bute

The town of Dunoon has attracted holidaymakers since the paddle steamer was invented in the 1800s when tourists were ferried 'doon the watter' from Glasgow and other spots on the River Clyde. Not as old as many, this castle was built in 1820 by a former Lord Provost of Glasgow and has an illustrious ghost – Winston Churchill, no less. He stayed at the castle during the Second World War to draw up plans for the Normandy landings. Visitors and staff have claimed to smell a strong smell of cigars in the corridor outside the Winston Churchill Room. Members of staff have many and varied tales of spooky happenings at this castle, including seeing angels, disembodied voices and even the ghost of a baby. Mr Coats, a one-time owner of the castle, has also been spotted roaming about the place in spiritual form.

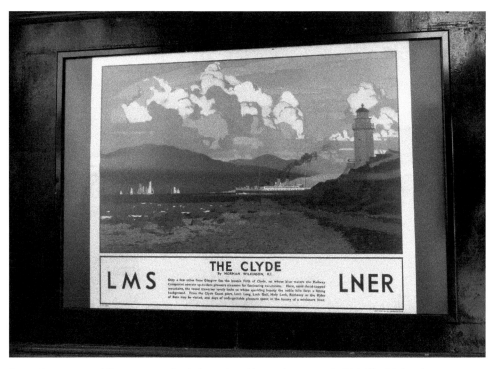

From Dunoon paddle steamers ferried tourists 'doon the watter'. (© Mike Pickup)

# Eilean Donan Castle, Kyle of Lochalsh

Representing the essence of a Scottish castle, this is one of the nation's most photographed. It appears on more calendars than any other and if you've seen a picture of a brooding highland castle on a tin of shortbread, it will probably be this one.

The castle is built on an island where Loch Duich, Loch Long and Loch Alsh meet and is a popular location for films, advertisements, fashion shoots and music videos. It is the star of tv shows and films and was the Scottish headquarters of MI6 in Bond film *The World Is Not Enough*. Many ghosts haunt this castle, so if you visit you'll certainly leave shaken and stirred.

The first fortified structure was built here in the early thirteenth century as a defensive measure, protecting the lands of Kintail against marauding Vikings. From the middle of that same century, this was the Sea Kingdom of the Lord of the Isles because the sea was the main highway. With its soaring towers and curtain wall, the castle encompassed almost the whole island.

Sailors of old believed that the island was home to mermaids and seal maidens. A common element in tales of seal maidens or selkies is that they cast off their sealskins in order to be able to shape-shift. Within these magical skins lies the power to return to seal form and therefore the sea. If the sealskin was lost the creature was doomed to remain in human form. If a human discovered the sealskin they could hold the maiden captive. Eilean Donan is also the burial grounds of the Otter Kings and their descendants still live there.

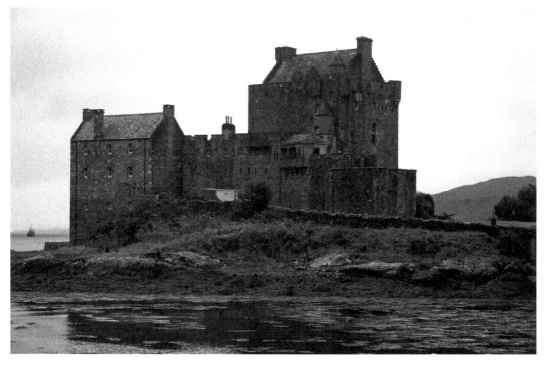

Eilean Donan Castle, one of Scotland's most picturesque. (© Gilly Pickup)

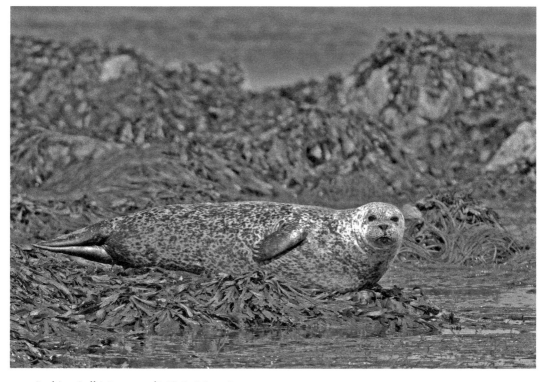

Is this a 'selkie' or a seal? (© L. Moyse)

What's more, it isn't only Loch Ness that harbours a creature of the deep; Loch Duich has one too. Since this is a sea loch the occasionally seen 'reptilian neck' of the monster might be the dorsal fin of a killer whale. Of course, this does not explain the nature of the Loch Ness Monster since Loch Ness is an inland freshwater loch.

Eilean Donan played a role in the Jacobite risings which ultimately culminated in the castle's destruction. In 1719 Jacobite William Mackenzie, the Earl of Seaforth, had the castle garrisoned by forty-six Spanish marines who supported the Jacobite cause. The intention was to launch a second Armada and a main force would land in the south of England. Prior to that there would be an attack in north-west Scotland to divert attention. Anyway, the English government found out about the intended uprising and dispatched three armed Royal Navy frigates to subdue matters. They sailed into Loch Alsh and Loch Duich and bombarded Eilean Donan Castle for three days, with only limited success due to the strength of the castle walls. It was decided the only thing to do was to send men ashore. It didn't take them long to overwhelm the Spanish defenders. The garrison surrendered and government troops blew up what remained of the castle to prevent it being used again along with barrels of Spanish gunpowder which were stored inside.

Eilean Donan Castle was no more – or was it? For the best part of 200 years, the stark castle ruins lay neglected and open to the elements. Then Lt Colonel John Macrae-Gilstrap bought the island and started reconstruction of Eilean Donan, which was completed in 1932.

However, it was discovered that the castle had not been empty while derelict. The spirit of a Spanish soldier is often seen wandering round what is now the gift shop. A scary sight as he has his head tucked under his arm!

Besides a selection of fine furniture in the banqueting hall, there is a fragment of tartan which belonged to Bonnie Prince Charlie and a lock of James III's hair.

Other ghostly apparitions include one known as 'Lady Mary' who haunts one of the bedrooms, while some floating heads have been seen 1331 in what was the Great Hall – probably due to the Earl of Moray who hung sixteen Mackenzie heads on the walls after he executed them for law-breaking.

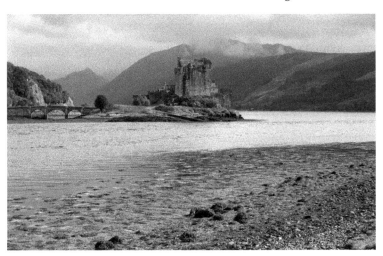

*Above left*: Eilean Donan Castle, where the sea is the main highway. (© Gilly Pickup)

*Above right*: Image of Scotland – tartan and a sporran. (© Gilly Pickup)

# Alloa Tower, Alloa, Clackmannanshire

This 700-year-old keep is home to much spectral activity and more previous occupants who can't bear to leave. In the dungeon a long-dead man appears to some of those who go down there. He lies on the stone floor in agony, his foot bloodied with bones visible – half eaten by rats. A ghostly girl kneels down and tries to help him by bandaging it. That's bad enough, but there are heart-rending cries emanating from a well which a young girl fell into hundreds of years ago. A few yards from that a woman dressed in black sings lullabies as she gently rocks a cradle.

The mansion next door was burned to the ground in the early 1800s and on the anniversary, people have noticed the acrid smell of burning. In the Charter Room, a young boy cries; standing alongside him is a man with piercing eyes. If all that isn't scary enough, the Solar Room is even more frightening. Visitors entering there have said they felt overcome by the feeling that they are being strangled.

A ghostly woman rocks this cradle. (© L. Moyse)

# Ackergill Tower, Wick, Caithness

This fifteenth-century tower has an extraordinarily grim history. The fortress was previously owned by the notorious Keith family who were constantly in battle with their neighbours, the Gunns. Their feud, which can be traced back to 1476, was one of revenge murders on both sides.

In the early 1400s, Dugald Keith abducted Helen Gunn, referred to as the 'Beauty of Braemore'. He kidnapped her on her wedding night no less and carried her back to the tower. Rather than give in to his advances she threw herself from the tower's battlements to her death.

Helen now walks around the tower from time to time and her wistful figure has been seen at night looking out of the window. A member of staff was seriously spooked when three nights running, a glass of water by her bedside flew off the table with no explanation.

# Aberdeenshire's Castles

I'll finish this chapter with stories about some of the castles in Aberdeenshire. Do you know there are more castles in Aberdeenshire than anywhere else in Scotland? That's saying something. It has so many that it even has its own 'castle trail'. It's well worth a visit if you're up that way. I haven't included all of those that have a presence or two. If I did, there'd be no space in the book for any more chapters.

Beautiful Aberdeenshire scenery. (© Gilly Pickup)

# Craigievar Castle, Aberdeenshire

Disney-esque in appearance, fairy-tale Craigievar Castle, all pink granite, multiple turrets, fanciful towers, gables, gargoyles and chimney stacks, was built in the 1600s by flamboyant Aberdeen merchant William Forbes, brother of the Bishop

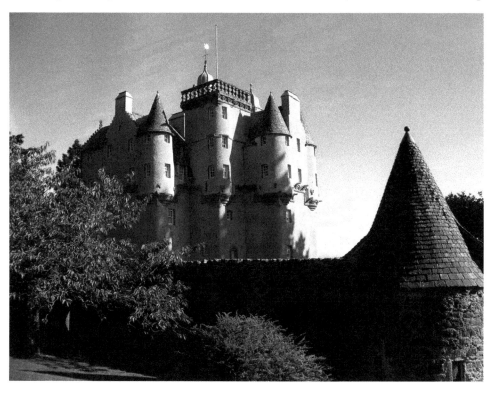

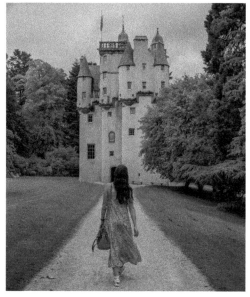

*Above*: Fairy-tale Craigievar Castle.
(© Ian Davidson and NTS photo library)

*Left*: Craigievar Castle, built in the 1600s.
(© VisitBritain and Romana Jones)

of Aberdeen. The seven-storey castle has a musicians' gallery and some of Scotland's best-crafted plasterwork ceilings which depict, among other things, Roman emperors' heads. There's also a hidden staircase.

Craigievar's charm made it an early tourist attraction and it attracted illustrious personages including Queen Victoria, Prince Albert and crowned heads of Europe. Visitors can see the Blue Room, which is the 'ghost' room and is where you can hear about the shadowy humans and strange happenings and doors that open and close all by themselves. Some have watched in horror as a candle has lifted itself off a mantelpiece and floated in mid-air. Yes, really! You might just catch a spectral cocktail party too. These are always fun affairs with plenty of lively Scottish music, disembodied voices and laughter. Oh, and you might see apparitions of children playing. If you pay a visit to Craigievar and feel your sleeve being tugged, don't worry. It'll just be one of the bairns wanting you to join in their game.

# Castle Fraser, Aberdeenshire

Castle Fraser is full of quirky features – there is everything to set your imagination off at a tangent from secret staircases and trapdoors to a spyhole. Over the years there have been numerous sightings of a young woman who was murdered in the Green Room. Her bloodied body, dragged down the round tower, stained the steps. The marks could not be removed so were covered with the wooden panelling that is still there. If you happen to spot a lady dressed in a long black gown, then it's fairly

You might hear ghostly music when you visit Castle Fraser. (© L. Moyse)

Castle Fraser garden. (© Gilly Pickup)

likely you are looking at the ghost of Lady Blanche Drummond who died in 1874. She wanders listlessly around the castle and sometimes ventures out into the gardens. When you go into the Great Hall … ssh! Listen carefully and you will probably hear ghostly whispers, laughter and music, none of which are of this world.

## Crathes Castle, Aberdeenshire

Step inside the Green Lady's room at Crathes Castle and you will feel a chill run down your spine. Why? This is said to be caused by the ghost of a servant who fell pregnant and likes to return to the castle. You might just catch a glimpse of this Green Lady as she paces back and forth, sometimes carrying a baby in her arms. A grisly discovery in the 1800s adds a sinister twist to the tale, the remains of a child were uncovered beneath the hearthstone of the same fireplace.

There is also a stranger-than-usual ghostly apparition – a spooky block of ice that appears in the castle from time to time. Why? No one seems to know. Meanwhile the tower house is home to a White Lady. When she was alive, Bertha – that was her name – and Alexander Burnett, the laird, were in a romantic liaison. They were distant relatives. However, Alexander's mum, Lady Agnes, felt that Bertha wasn't fit for her son. She had big plans for her dear boy, so she poisoned Bertha. Nice! Now Bertha returns on the anniversary of her murder.

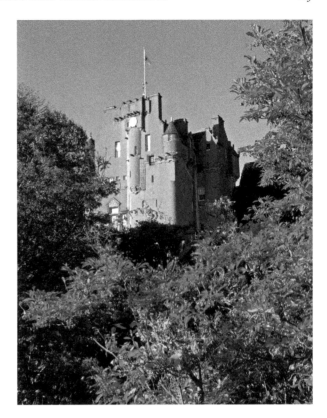

Crathes Castle. Will you see something spooky when you visit? (© Brian & Nina Chapple and NTS)

# Fyvie Castle, Aberdeenshire

Phantoms and secret chambers, it's what you expect of old castles really. Fyvie Castle doesn't disappoint – it has both. Turrets, crow-stepped gables and finials in the form of musicians create a splendid façade on the castle's south front while the castle's five towers bear witness to the five families who have owned it.

One of the castle's phantoms is Lilias Drummond, second wife of the Earl of Dunfermline, who has reportedly been seen wandering forlornly along corridors. She failed to give her husband Alexander Seton a son, so he locked her up, starved her to death and married her cousin, Grizel Leslie. On their wedding night, Lilias' name was found freshly scratched into the wall.

Lilias often comes back to her old home and when visitors encounter her spirit, they report a sudden drop in temperature and the smell of roses fills the air.

The castle also has a ghostly drummer and there is a room within the Meldrum Tower, where – according to legend – workmen found a skeleton. The remains were given a proper burial but later, residents began to experience unexplained happenings and hear strange noises. The laird decided it must have been wrong to move the skeleton and decided to have it returned to its original resting place behind the bedroom wall. As soon as that happened, the hauntings stopped. However, the room must remain forever sealed. Woe betide anyone who enters here – if they do, disaster will surely befall them!

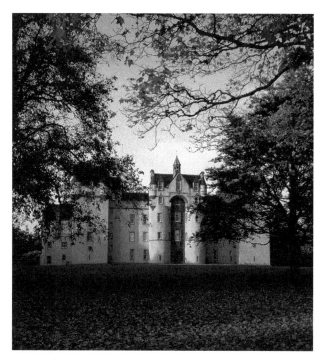

*Left*: Fyvie Castle – best keep your wits about you here. (© Mark Leman & NTS photo library)

*Below*: A haunted room in Fyvie Castle. (© Gilly Pickup)

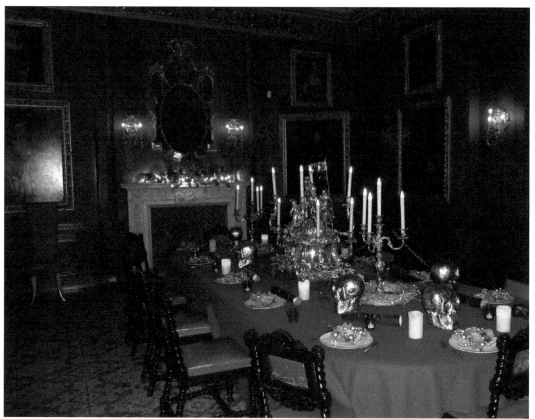

# Kildrummy Castle, Aberdeenshire

So we come to the last Aberdeenshire castle in the book. This one was captured by Edward I of England in 1296 and provided shelter for Robert the Bruce's queen and daughter, before enduring a great siege in 1306. That was when the Bruce's younger brother was captured after the castle was set alight. The traitor was Osbourne, the castle blacksmith, and he was rewarded for his deed. Yes indeed. He got lots of gold – poured molten down his throat. He still comes back from time to time, probably lamenting what he did.

'Bobbing John', the 11th Earl, used Kildrummy as the headquarters to organise the final details of the 1715 Jacobite Rising. When this proved to be a failure, the Earl fled to France and the castle fell into ruin.

**A Ghostly Snippet:** There are times when ghosts attach themselves to objects rather than places and will follow these objects even if they are moved.

Spirits of the dark. (© YTB A5 author's collection Gilly Pickup)

# Churches, Abbeys and a Cathedral

## Rosslyn Chapel, Midlothian

A few miles south-east of Edinburgh lies Rosslyn Chapel, made famous by Dan Brown's book and the film *The Da Vinci Code*. The 600-year-old chapel, identified as one of Scotland's most mysterious places, has been described as a 'tapestry in stone' because of its carvings which relate to biblical, masonic and pagan themes.

One of the most impressive is the Apprentice Pillar said to have been carved by an apprentice to the then master mason. The story goes that the master went to Rome to seek inspiration and when he got back was amazed and angry to discover that his apprentice had completed the pillar perfectly. The jealous master struck the boy dead on the spot. There is definitely something really odd here because some of the carvings are beyond strange. Take for instance the carving of a vine which some experts say is identical to the helix DNA structure which is at the core of all life. How could this be possible be unless the ancient peoples knew about molecular DNA? A carving of

Apparitions aplenty haunt this chapel. (© Gilly Pickup)

corn has also led to speculation because the chapel predates Christopher Columbus' journey to the New World, so Scotland would have had no idea about America's indigenous plant life. Probably most spooky of all however are the carvings of the green man. Over a hundred of them decorate the chapel, which when you think about it is really peculiar because the green man symbolises pagan gods. Christianity had banished them for good. Why then are they dotted all round this chapel?

There are whispers that the Holy Grail is hidden in here together with other religious treasures. Rosslyn has also been connected with the Knights Templar, the Ark of the Covenant and the origins of Freemasonry.

Apparitions aplenty have been seen inside the chapel including a spectral figure who sometimes appears in front of worshippers. Some say that he is the apprentice who carved the pillar.

## Melrose Abbey, Roxburghshire

Lots of phantoms roam the ruins of the once magnificent Melrose Abbey. Indeed, it is haunted by several spirits including monks and a more sinister spirit, the ghost of Michael Scott who died in the thirteenth century. This highly intelligent man, an alchemist and astrologer who spoke Greek and Latin, was also a practitioner of the black arts. He allegedly possessed supernatural powers – or could it simply have been that he came over as a daunting intellectual, whose knowledge seemed threatening to less educated people? Whatever the reason, this man inspired fear among those who crossed his path, both in life and after death. Nowadays, people still report feeling an ominous chill in the air when standing near his grave. Spookier still, a ghostly figure which can allegedly be seen slithering snake-like along the ground is said to be a manifestation of his spirit …

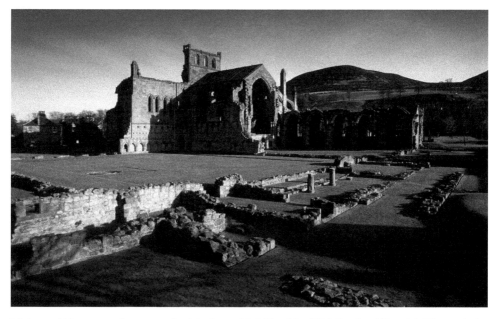

Melrose Abbey – no shortage of spirits here. (© P Tomkins/VisitScotland/Scottish Viewpoint)

It's sensible not to visit here at night. (© Gilly Pickup)

## St Andrew's Cathedral, Fife

This cathedral has not one, but two, ghosts. One is a monk who visitors sometimes meet on the stairs at St Rule's Tower. The other is a White Lady, who has been sighted gliding through the grounds before vanishing at the entrance to the tower. A story goes that stonemasons repairing the haunted tower accidentally broke through into a sealed chamber where they found the body of a young woman wearing a white dress and white gloves. Who was she in this life? No one seems to know.

St Andrews Cathedral.
(© Gilly Pickup)

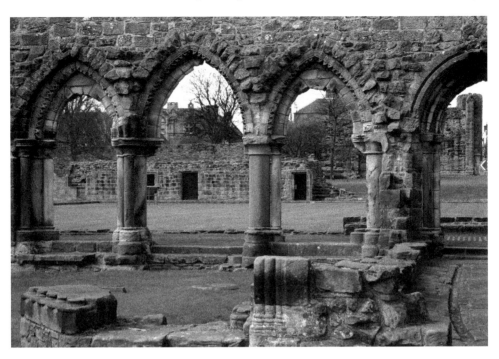

St Andrews cathedral grounds. (© Gilly Pickup)

# Iona Abbey, Isle of Iona

This glorious holy island is the burial place of sixty Scottish, Irish and Norwegian kings. It was St Columba who founded the monastery here in 563. Its history is almost tangible; no wonder visitors have experienced phantom bells and ghostly music. This is an enchanted island which harbours secrets and spectres galore.

**A Ghostly Snippet:** Ghosts may exist in a state of confusion and not have a clue what happened to them, why they are here, or why you cannot see or hear them.

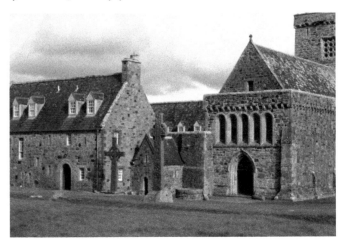

Iona Abbey founded by St Columba. (© Gilly Pickup)

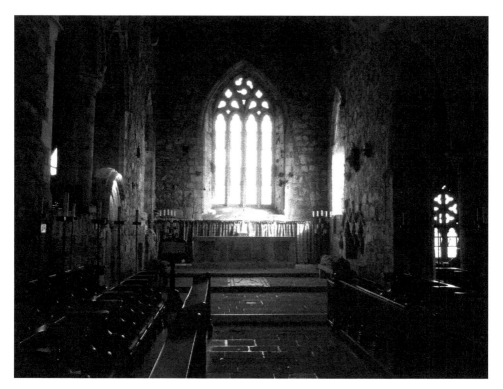

Inside Iona Abbey. (© Mike Pickup)

Spirits in the room. (© YTB)

# Haunted Roads, a Bridge and a Railway

Yes it's true, Scotland's spooks get everywhere. What would you do if you were driving along what appeared to be a perfectly normal road and you came upon a driverless, speeding car or a hooded figure with no face? It's enough to make your hair stand on end.

Some roads are just best avoided in the dark. (© ABV)

# A75 Dumfries and Galloway

There are stretches of the A75 which simply thrum with paranormal activity. One of the busiest in terms of paranormal activity is that from Annan to Gretna via Eastriggs; the other a wide, straight section of road known as the Kinmount Straight. Drivers have reported all sorts of weird things here including phantom hitch-hikers, spectral beasts and occasionally – mind now, if you're driving along here in the dark – a person wearing a hood but who has no face and who may suddenly appear in front of your vehicle. If that doesn't give you the heebie-jeebies, then I don't know what will.

In the 1960s two brothers driving along reported all manner of weird apparitions which suddenly appeared before them, including giant cats, wild dogs, goats and, according to reports of the day, 'stranger creatures which cannot be described'.

There are several reports of drivers who have witnessed a group of exhausted-looking, bedraggled men and women making their way along the road pulling handcarts behind them, some carrying bundles of belongings. Josie Strang, whose journey to work often takes her along this road at night, has witnessed this unsettling sight. She told me, 'I had heard tales of hauntings on this road, but dismissed them. I'm probably the last person to believe in ghosts and stuff like that. One night though around 10 p.m. I was driving along here when I saw what looked like a large group of people walking slowly along the road, heading north. It struck me at the time how tired they seemed to be. I slowed right down and made to pass them. As I pulled out to avoid them though, my God – they vanished! What a state I was in. I phoned the police, though I don't know what I expected them to do! but they just said, "Take it easy, it's only the medieval camp followers – some folks have seen them before."'

Who knows who or what you might meet on the open road? (© B. Thompson)

# Electric Brae, Ayrshire

Now, this entry isn't strictly paranormal, but I felt it was weird enough to warrant inclusion. I hope you think so too.

This road attracts lots of visitors who want to witness the unusual sight of a car rolling uphill, as if drawn by some mysterious force. In days gone by people believed the road was haunted by witches but more recent theories suggest the phenomenon is simply an optical illusion.

Electric Brae, known locally as Croy Brae – 'brae' is the Scottish word for 'hill' – is where cars left in neutral appear to roll uphill. You could drive along this quarter-mile stretch of road between Dunure and Croy Bay without batting an eyelid. However, if you try to park your car and release the handbrake, that's when things go awry and you get the odd sensation of starting to roll uphill. People used to stop on the road to do this as a bit of fun, but it is more sensible and safer to use the lay-by which the council provided. A stone at the location explains the effect is because the inland end of this stretch of road is 17 feet higher than the coastal end. Due to the slope of the surrounding landscape, the road appears to incline from the coastal end down to the inland end. Even with the explanation, the illusion is powerful and the resulting effect weird.

# A9 Scottish Highlands

Another of Scotland's haunted roads is the A9, where there have been spectral sightings of four horses pulling a large yellow coach. There have also been reports of a man dressed in Victorian clothing riding a horse at speed by the Mound between Dornoch and Golspie. When people get closer to him, he simply vanishes!

A yellow coach similar to one you may see on the A9. (© Mike Pickup)

Spectral sightings may spook you. (© Gilly Pickup)

## A93 North of Blairgowrie, Perthshire

A ghost dog which frightens other dogs as well as people patrols this stretch of road. Described as a 'hellhound', a mythological dog which used to guard Underworld entrances, it must be a scary sight! Legend has it that if you stare straight into the eyes of such an otherworldly beast, you will be bound to die …

## A87 Portree to Sligachan, Isle of Skye

If you're driving along the east of the island during the day and an Austin Seven with its headlights on overtakes you at high speed, try not to be too alarmed. Some drivers have said they had to pull over to let the car overtake them, perhaps thinking it's a sensible thing to do. But then! Guess what happens? The Austin Seven simply vanishes into thin air.

The sightings date back to the 1940s and a story goes that the driver was a church minister who caused a terrible accident and couldn't cope with the consequences. He was driven insane because of it. The apparition is mentioned by author Elizabeth Byrd in her book *A Strange and Seeing Time*.

On the Isle of Skye. (© Gilly Pickup)

The magical island of Skye. (© Gilly Pickup)

# The Grey Train of Dunphail, Morayshire

Although the Dava railway line is long gone, walkers on this trail occasionally still report seeing a ghostly driverless train, lights blazing, carriages empty, speeding along above the tracks. Yes, above the tracks, not on the ground. Spotted in the 1920s and again in the 1960s and 1970s, there is little or no explanation for the apparition. If you know more about it, do let me know.

What would you do if you saw a ghostly driverless train? (© Gilly Pickup)

A train speeding along may not belong to this world. (© L. Moyse)

# Old Tay Bridge, Dundee

Britain's worst ever bridge disaster happened on 28 December 1879, the night of a terrible storm. It was only two years after it was built that the Tay Bridge collapsed, plunging a six-carriage passenger train into the water far below, killing all seventy-five

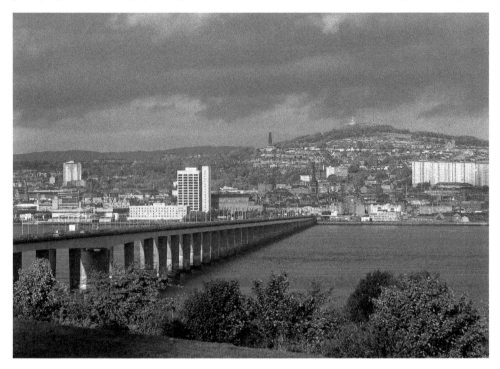

'New' Tay Bridge. (© Visit Scotland/Scottish Viewpoint)

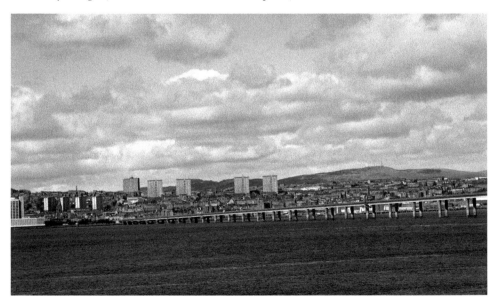

River Tay and the Tay Bridge. (© Gilly Pickup)

passengers. The bridge was rebuilt but since then, every year on the anniversary of the disaster, a ghost train has been seen crossing the river where the old bridge stood, disappearing where the bridge collapsed. What remains of the old bridge's pillars can still be seen beside the current Tay Bridge.

**A Ghostly Snippet:** Spirits can often be protective of the families they haunt.

Spirits appear in all guises. (© L. Moyse)

CHAPTER FOUR

# Houses – Great and Not So Great

## Pollok House, Glasgow

Sometime in the 1670s, a mute serving girl called Janet Douglas arrived to work at the Pollok estate of Sir George Maxwell. Not long after her arrival, George suddenly fell ill. It was odd because just at that same time Janet regained her speech and when she did so, accused five local people of consorting with the Devil.

   The story of their trial and subsequent burning at the stake has intrigued historians over the centuries, as has the story of Janet herself. The tale is that she then set sail for America where she was involved in the Salem witch trials of 1692. These days there are a couple of rooms in the house where Janet occasionally likes to make an appearance and visitors have reported feeling cold spots when viewing the house on guided tours.

A warning or beware the consequences. (© Gilly Pickup)

# Haddo House, Aberdeenshire

Built on the site of an ancient castle, Haddo House combines striking Georgian architecture with Victorian interiors. It was home to the well-to-do Gordon family for over 400 years. One member of the family, George Hamilton-Gordon, 4th Earl of Aberdeen, was Prime Minister of Great Britain in the nineteenth century.

Seriously sinister shenanigans abound in one of the bedrooms, thought to be caused by the spirit of ginger-haired Archibald Gordon, son of the Marquis of Aberdeen who was killed in the early 1900s in a road accident. Dressed in tweeds, Archie's ghost has been seen smiling as he walks alongside tour groups, some of whom see him while others don't.

Haddo also has a darker side with locked attic doors shaking frantically as if someone is determined to get out and staff have been chased by spirits through the servants' corridors and cellars.

Haddo House, which was used as a maternity hospital during the Second World War, was acquired by the National Trust for Scotland in 1978 and opened to the public the following year.

The haunted bedroom in Haddo House. (© Gilly Pickup)

# Leith Hall, Aberdeenshire

Leith Hall was home to the Leith-Hay family for over three centuries until their time here was brought to a sad end by a motorcycle accident in 1939. The building is haunted by the ghost of John Leith, who was shot in 1763 in a drunken brawl in Aberdeen. Although he was brought home, he died three days later on Christmas Day. Dressed in green trousers and shirt, he appears in front of startled visitors looking as if he is in great pain. He has a grubby white bandage wrapped around his head which covers his eyes. Other ghostly sightings include apparitions of a family dog and children at play.

# The Hill House

This Charles Rennie Mackintosh masterpiece was built in the early 1900s for Glasgow publisher Walter Blackie, who likes to come back to check that all is well from time to time. Dressed in a long black cape, he emerges from the dressing room, heads along corridors then vanishes in the main bedroom. Oh, and something else: please don't be concerned if you smell pipe smoke in or around the library; smoking was one of Walter's favourite pastimes.

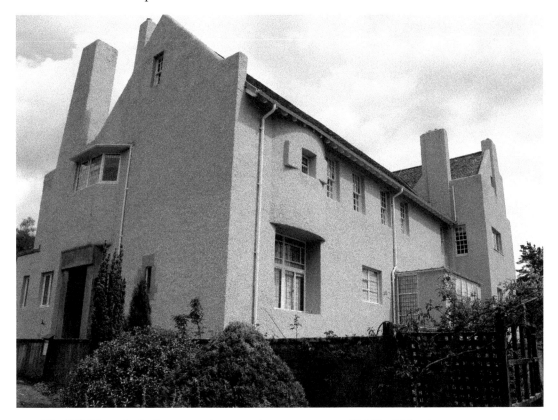

The Hill House looks innocuous but contains many secrets. (© Mike Pickup)

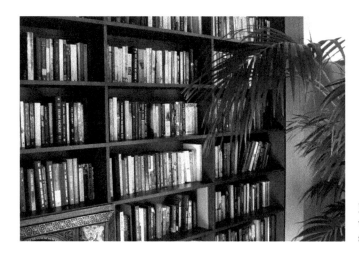

Library in the Hill House where you may smell pipe smoke. (© Gilly Pickup)

# House of Dun, Montrose, Angus

Beware the headless horseman who roams the lanes around Dun at night. This Georgian mansion and surrounding estate hold many dark secrets including that of a harpist murdered at the Den of Dun. Now he appears to some on dark wintry nights playing musical laments. If you're – ahem – lucky, you may also encounter the spirit of a knight who, upon returning from the Crusades, discovered his wife had married his friend. A sword fight took place and the knight killed his friend, impaling him on a tree near the House of Dun.

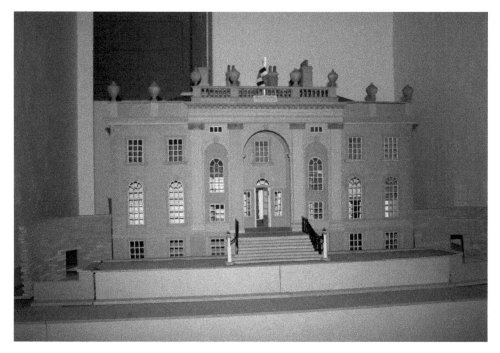

A model of the House of Dun. (© Gilly Pickup)

Inside the House of Dun. (© Gilly Pickup)

## Traquair House, near Innerleithen, Peeblesshire

This house has been continuously inhabited for longer than any other in Scotland and has hosted an incredible twenty-seven Scottish monarchs. Mary, Queen of Scots came here with Lord Darnley in 1566 and the cradle in which their infant, who would become King James VI of Scotland and I of England, slept is still in the room they occupied. Bonnie Prince Charlie arrived during his 1745 campaign to reclaim the throne. At the time hopes of success were running high and as he left Traquair through the Bear Gates – so called because of the two stone bears that surmount the sturdy gateposts – the 5th Earl of Traquair locked them behind him and vowed that they would never again be opened until a Stewart sat on the throne again. When hopes for a Stewart restoration came to a bloody end in the horror that was Culloden, the gates stayed locked. Today visitors reach the house by a driveway bypassing the Bear Gates.

A portrait of Lady Louisa Stewart, sister of the 9th Earl of Traquair, and the last Stewart lady to live there, hangs in the house. She died in 1896 just before her 100th birthday. One day in the 1950s a farmer tending his crops saw a lady in old-fashioned clothing come towards him. She walked straight past him walking through a closed gate into the wood where she disappeared. Later he identified the fabric of the dress that his ghostly visitor was wearing from a book of fabrics shown to him by a woman who had been Lady Louisa's dressmaker. Weird or what?

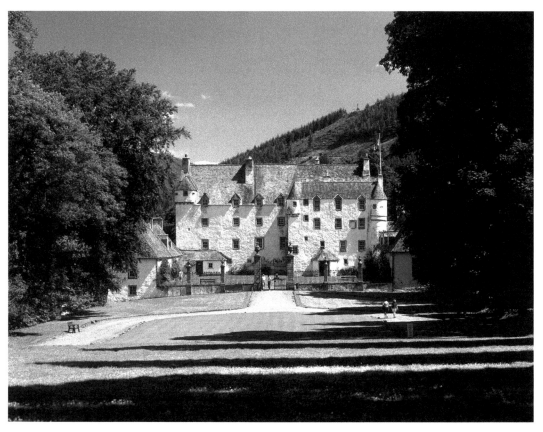

No. 55 Traquair House. (© L Moyse)

A figure from another world was seen at Traquair House. (© L. Moyse)

# Hugh Miller's Cottage and Museum, Cromarty, Ross-shire

Geologist and fossil hunter Hugh Miller wrote spine-chilling ghost stories in this cottage where he was born. If you have the chance to visit, ask the tour guide to tell the story of the severed hand apparition that reached out to the boy Hugh the night his father was lost in a shipwreck. Learn about the visions which blighted Hugh's great-grandfather, buccaneer John Feddes, then visit the 'little antique room' where many an inexplicable occurrence has taken place. Will you see anything? Depending on when you visit, it's highly likely.

# Skaill House, Orkney

Built on top of an ancient Pictish burial ground, it's really no wonder that there are so many ghosts which roam in and around the grounds of Skaill House. From sightings of ghostly figures in empty rooms and instances including wafts of cigarette smoke when no one is smoking, there are many strange things to freak visitors out. The mansion's most famous ghost is called Ubby, believed to have been the man who created the small island in the nearby loch by dropping stones from his rowing boat. They say he died out there, though now haunts the wing of the house where he once lived.

There have been other sightings in the main house by both visitors and staff. One employee reported seeing the reflection of a tall man in the mirror, but when she

Skaill House, Orkney – many ghosts roam here. (© Gilly Pickup)

No. 58 A rowing boat – could it be Ubby's? (© Mike Pickup)

turned round, no one was there. A visitor in the gunroom said she asked a question about the house which was answered by a male staff member ... the only thing is, no males were working that day ...

There have also been sounds of doors opening and closing of their own accord. One thing that isn't up for question is that there are skeletons lying under the floorboards. During preparation of the house some years ago for its opening to the public, fifteen skeletons were discovered in the south wing and under the gravel in front of the east porch.

## Queensberry House, Edinburgh

When he was around ten years old, James Douglas, Earl of Drumlanrig, cooked a servant boy on a revolving spit in the kitchens of Edinburgh's Queensberry House, then ate most of him. The oven is still in the Parliament's Allowances Office and perhaps not surprisingly, it is said that the boy's ghost haunts the building.

The story began in 1689 when William Douglas, 1st Duke of Queensberry, bought Queensberry House. He died there in 1695. At the exact moment of his death, sailors on a ship off Sicily saw a coach and six careering madly up the to the crater of Mount Etna which was spewing boiling volcanic ash as if exiting the mouth of Hell. A sailor recognised one who sat in the coach as Queensberry. At the same time,

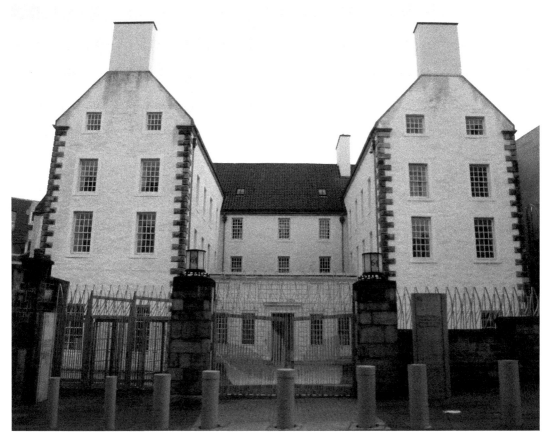

Queensberry House, Canongate, Edinburgh. (Author Kim Traynor from Under Creative Commons)

the Devil's voice was heard to boom, 'Make way for the Duke of Drumlanrig!' (one of Queensberry's subsidiary titles). The coach then vanished. Curse or merely legend? Whichever it was, misfortune certainly dogged the family for many years and it seems, continues to do so.

The daughter of the Duke, Anne, Countess of Wemyss, died a horrific death in 1700 after accidentally setting fire to her apron. Records tell that her 'nose was burnt off and her eyes burnt out'. As if that was not ghastly enough, when she opened her mouth to scream, 'the flame went in and burnt her tongue and throat'.

The cannibal Earl, James Douglas, insane second son of the 2nd Duke of Queensberry, was kept under lock and key in the house. The glory days of the second Duke, also named James Douglas, came in 1707 when as one of the Scottish commissioners who negotiated the Treaty of Union, he was largely responsible for ending Scotland's days as an independent nation and on 1 May 1707, after years of heated discussion and debate, England and Scotland became the United Kingdom of Great Britain. It was well known that Scotland, or North Britain as it was known in this period, would not adapt easily to this new relationship with England. This meant the English parliament became the British parliament with marginal readjustment to accommodate Scottish interests.

Overview of the
Garden Lobby with
Queensberry House
in the background.

It was therefore to be expected that on the night the treaty was ratified, Edinburgh was in turmoil. There were riots galore, though of course there were the odd few who saw the occasion as an excuse for a party. That night, the Duke decided that the best thing he could do was stay away from Queensberry House. It is somewhat ironic that this residence on the Canongate is now part of the Scottish Parliament buildings. Most of the staff were also away from the house that evening and unfortunately the servant who was charged with looking after mad James, the boy Earl, was not there either.

James managed to escape from his room in search of food following the cooking smells to the kitchen where he found the young servant busy with his chores. The young Earl, who had enormous strength, decided there and then to cook and eat the kitchen boy.

When the Duke returned home, he was horrified by the sight that met him: a cooked, half-eaten servant and his slavering mad son. He ordered his son to be killed immediately but this did not happen and all we know about the crazy boy Earl after that is that somehow, he was spirited away to England where some years later he died. Although the Duke tried to keep the story quiet, unsurprisingly the tale spread like wildfire. Scots against the treaty said the crime was a judgement on the Duke for favouring the union. A curse, no less.

Due to his mental state, the Earl could not succeed to the Dukedom, which passed to his younger brother Charles, who became 3rd Duke of Queensberry.

In 1720, Charles married his second cousin, Lady Catherine 'Kitty' Hyde. They often came to stay in Queensberry House. Unfortunately, Kitty was eccentric to the point of madness. Prior to her marriage she had been frequently confined in a straitjacket. She hated Scotland and the Scots.

One of Charles and Kitty's sons also inherited the family's mad streak. In 1754, on a journey to London, he galloped in front of a coach containing his mother, pulled out a pistol and shot himself dead. A year after that, more misfortune befell the family when his brother Charles, who had narrowly escaped death in an earthquake at Lisbon, also died.

The curse that dogged the Queensberry family did not end there. In 1858 the 8th Marquess, Lord Lieutenant for Dumfriesshire, shot himself dead with his own gun while out hunting. Deliberate or an accident? No one knows. In 1865 his second son, Lord Francis, was killed while climbing the Matterhorn. In 1891 the third son, Lord James Edward Sholto Douglas, committed suicide by cutting his throat in a London hotel. In 1895, Francis, another family member, was killed in a shooting accident, while another, Sholto, was arrested in California for insanity.

Lord Alfred 'Bosie' Douglas, son of the 9th Marquess, married in 1902 but his only child died insane. Lady Dorothy Douglas, daughter of the 11th Marquess, married an army officer whose alcoholism ruined them and left her living in poverty.

Even now, the curse or family misfortune throws black shadows across the lives of the Queensberry family and the current generation of the extended Douglas clan includes a former bank robber and a now deceased brother of Osama Bin Laden.

In 2009, thirty-four-year-old Lord Milo Douglas, third son of the present Marquess of Queensberry, threw himself to his death from the eighth floor of a building in London's Bayswater. Milo's father, the 12th Marquess, has been married three times with several children by four women. Referring to his son's suicide he remarked unemotionally, 'It's a terrible thing to happen but I guess it has to happen to somebody sometimes.' An example of endurance during adversity, but then could anything else be expected from a man with centuries of family catastrophes – or curses – behind him?

The ghost of the half-eaten servant boy appears from time to time and general opinion is that he will continue to do so until the Queensberry curse finally comes to an end.

Now, we look at some 'not so grand' abodes. After all, it's not only big, old buildings which feel the chill of ghostly presences you know. There are often weird goings-on in small, newer properties too. Some claims are of course, fanciful. Others are mere sensationalism. Many though, are just much too strange to be ignored. Full address details are not given because these are mainly housing association or social housing properties where people currently live.

kitchen in Queensberry House where a servant boy was cooked. (© Gilly Pickup)

## Kirkcaldy, Fife

In 2013 Fife Council officials were called to a house by a woman who claimed that a violent poltergeist was making her family's life a misery.

In fact, I should just say that most reports of ghostly goings-on in homes concern poltergeists – familiarly known as 'polts'. They often start by knocking or thumping on walls; occasionally some like to make scratching noises. They like to scare people and love it when they see people getting freaked out at the sight of furniture moving of its own accord.

Reports from this particular home included loud noises coming from the attic, electrical appliances switching on and off and doors were violently flung open and closed. The occupier had called in a medium who went into a trance and said the spirit of the last occupant who had died in the house was still there, together with a dead brother and an old woman. It was concluded that the claim could neither be proved nor disproved but had been taken seriously. The woman and her family were moved to another property and the new tenant did not report any problems.

## Tain, Easter Ross

A distraught toddler was targeted by a poltergeist at a house in Tain. She said she saw someone who walked through the wall and lights that switched on and off of

Mind out for ghosts. (© Gilly Pickup)

their own accord. The girl was also plagued by a ghostly man and his phantom dog. The terrified family left their home and moved elsewhere but before doing so, a Church of Scotland minister was called in and performed a blessing to prevent the phantoms from moving with the family to their new home.

## Pollokshields, Glasgow

In 1975 a poltergeist caused no end of panic in this family house in Maxwell Park. Doctors, ministers, spiritualists and policemen came to see what it was all about. A senior police officer had to take some of his men off of the case when they found themselves being mysteriously pelted with stones and eggs. It was mayhem. Water ran down the walls of one bedroom without any defined source, light bulbs flickered, an ornament on the mantelpiece moved by itself and settled on a table at the other side of the room. Eventually a paranormal investigator and priest discovered the source of the trouble was a teenager who was being targeted by the ghosts. After an exorcism was carried out, the trouble stopped.

## Kirkintilloch, near Glasgow

A scared young woman was forced from her home in 2012 by a vengeful spirit that she believed was trying to communicate through her four-year-old son. She fled the first-floor flat in Friar's Court after a series of terrifying incidents left her fearing for the lives of her children. Mysterious voices, a disappearing crucifix and doors banging

when no one was near terrified the twenty-six-year-old so much that she had a priest bless the house. She also called in spiritualists but the strange events did not cease. There was nothing else for it but to move from the housing association property. She later found out that the previous tenant had experienced similar strange goings-on.

## Rutherglen, Lanarkshire

Spooky goings-on at a house here made headlines a few years ago. A woman and her son called the police after many bizarre events happened at the property and which began to take their toll on the inhabitants. Police officers reported witnessing unexplained phenomena including clothes and a mobile phone flying across a room while an oven door opened and closed by itself. A Catholic priest performed an exorcism and soon after that the events stopped.

## Dalkeith, East Lothian

In 2012 a mother and her two daughters started to see strange things at their home. A man wearing a dark suit and a blonde woman in a white nightgown appeared to the occupants, night after night. A child's rocking horse would rock violently backwards and forwards at random times. The householders became so terrified of being alone in

The child's rocking horse plagued by a poltergeist. (© Gilly Pickup)

the house they started sleeping together in the living room. A blessing from a Church of Scotland minister only seemed to exacerbate the situation. Paranormal investigators who visited said there was a distressed spirit named Thomas Laidlaw in the house. He was politely asked to leave and the supernatural goings-on ended.

## Sauchie, Clackmannanshire

In 1987 residents of three adjoining houses claimed they were all being spooked by ghosts. All of them were experiencing noises issuing from the attics, saw cutlery flying through the air, a couple carrying a baby was seen in a bedroom late one night while one of the female residents went into a trance and began speaking in tongues. Paranormal investigators were called in and performed a cleansing ritual on the properties in a bid to rid them of the supernatural, but there is no record as to whether it helped or not as each of the families moved out soon after.

## ... And Finally, a Private Flat, Forfar, Angus

A strange tale of a visit from beyond the grave occurred in June 1993 when Debbie* who was staying in a spare room at her friend Maggie's* flat was woken in the early hours of the morning by a girl she didn't know. The girl seemed annoyed and asked Debbie why she was sleeping in her bed. Debbie apologised and explained that she had been invited to stay there for a couple of nights while she had some work done in her own home. The girl simply turned round left the room and Debbie fell asleep again. The following morning she mentioned the incident to Maggie who turned pale and explained that her flatmate who normally slept there was in hospital after a suicide attempt. They later discovered that the girl, the vision who had spoken to Debbie, had died during the night.
   *not their real names

**A Ghostly Snippet:** There are different kinds of ghost: poltergeists, spirits, full or partial apparitions, demons and orbs.

# Jails and Places of Incarceration

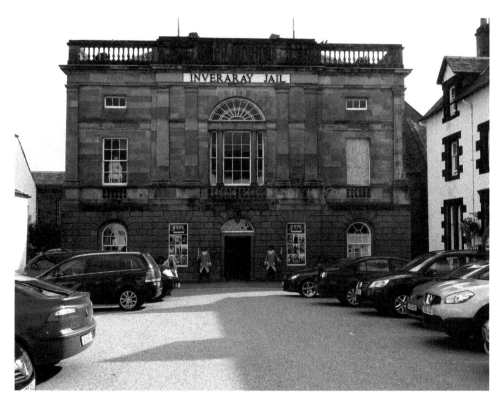

Inveraray jail. (© Gilly Pickup)

## Inveraray Jail, Argyll

Nowadays Inveraray Jail has the reputation of being one of Scotland's most haunted locations. Spiritual circles have certified that this is one the most haunted properties around. A popular visitor attraction, the museum also holds regular overnight paranormal investigations and ghost hunts so that visitors can communicate with the spirits of the dead.

Inveraray, seat of the Duke of Argyll, was the principal county town of Argyll and from the mid-eighteenth century, courts met in the Town House on Front Street. The ground floor below the courtroom was the county prison.

A psychic medium recently picked up on a woman's presence in the old prison block. She came across as a nasty character who disliked children. The event continued in the dark with interactive experiments which included filmed vigils, electronic voice experiments and a variety of other ghost-hunting gadgets. One participant said during the experiment he felt as if he had been punched in the stomach and reported a green light travelling through the air. Voice recordings, recorded below human hearing frequency, picked up the sound of voices, angry shouts and footsteps in response to questions asked by participants.

If you think about it though, perhaps it is no wonder that these are unquiet spirits; this must have been an awful place in days gone by. Thousands of men, women and children were sentenced to be locked up here in the 1800s. Most male prisoners spent much of their time making herring nets or picked oakum – fibre from short lengths of rope that had been picked apart. Some were employed as tailors, shoemakers or joiners. Female prisoners also picked oakum, and others knitted stockings or sewed.

Life in prison was made more unpleasant by hard-labour tasks including turning the crank machine or climbing the treadwheel. It was thought that these exhausting activities would act as a deterrent and discourage prisoners from committing further crimes when they were released. Male prisoners had to turn the handle of the crank machine thousands of times daily. The number of revolutions was registered on the dial. The warder could make the task harder by tightening a screw – hence 'screw' became a slang word for prison warder.

The treadmill or treadwheel was like the elongated wheel of a paddle steamer with twenty-four steps instead of paddles. Prisoners would hold onto a bar or strap in individual compartments over these steps. The wheel turned under their weight. Prisoners had to keep climbing or fall off. It was exhausting. Though they were a feature in English jails, few treadwheels were built in Scotland and all were removed by the 1840s.

Records show that child prisoners included nine-year-old Duncan Blair jailed for fourteen days in 1855 for stealing a petticoat. In 1872 eleven-year-old Mary MacDonald stole an umbrella and was also sentenced to fourteen days and five years' schooling. How times have changed!

# The Tolbooth Centre, Jail Wynd, Stirling

Nowadays this is Stirling's music and arts centre but was originally a courtroom given the dubious accolade 'Worst Jail in Britain' according to an 1842 Commission.

It is haunted by the restless spirit of a murderer who died in here. This ghost is held responsible for the hair-raising, sinister goings-on which have occurred since the theatre reopened after being renovated. During this time a skeleton was discovered still wearing the boots he died in more than 150 years ago. Everyone hoped his marrow-chilling antics would cease after he was given a proper burial but no, not at all; he continues to make the flesh creep. All manner of scary goings-on has been reported, including sounds of someone being dragged across the floor of what was the condemned cell. Bar staff have reported wine glasses flying off shelves while a ticket seller saw door handles turn and doors shake violently when no one else was around. She left her job soon after. Can't blame her really. In fact, this wayward wraith is so nerve-jangling that he may just have to be exorcised.

Door to the worst jail in Britain. (© Mike Pickup)

## The Tolbooth Museum, Castle Street, Aberdeen

Before you think that this entry has slotted itself into the wrong section, it hasn't. Although a museum now, this building is a well-preserved example of a seventeenth-century Scottish jail. The original building dating from 1393 was where tolls were collected for goods that were bought and sold. Further down the line its role changed to that of a holding place for prisoners about to be tried at court and became a general prison.

Over the centuries many deaths occurred in the jail, either by means of execution or as a result of torture. With all this pain and suffering it is no surprise that the Tolbooth museum is an extremely haunted building with several permanent ghosts. All those emotions and executions have left their mark.

Several cells still exist in their original format, restored to how they would have looked when used as holding cells. The most famous inmate was Janet Walker convicted of witchcraft in the seventeenth century. Known as the Fittie Witch, she met her gruesome end by strangulation followed by burning – a fate often doled out to supposed witches. Actually, burnings were rare in Aberdeen except in 1597 when King James VI encouraged a witch-hunt and twenty folks were rounded up, suspected of the black arts and burned.

The Tolbooth ghosts have manifested themselves to staff and visitors over the years. People have heard spectral singing, a noise of jangling keys coming from the jailer's room and have witnessed dark shadows accompanied by ghostly footsteps. The building has been examined by paranormal investigators and ghost hunters while television's *Most Haunted* team carried out a paranormal investigation here. Visitors have witnessed an inexplicable white mist and a mysterious orange light. Sounds of shuffling feet, clanking chains and cold feelings have been reported. Some say

All things creepy. (© R. Campbell)

they find it difficult to breathe while others have reported the feeling of something tightening around their necks …

A more modern ghost, described as a tiny man no more than 4 feet tall, makes his presence known occasionally. He is dressed in 1920s clothing and a trilby hat. It is suggested that he is so small because the floor has been raised since his time.

The Aberdeen University-based paranormal team held an investigation here with three guest mediums and investigation equipment including a camcorder, trigger objects, EMF meter, laser thermometer and beam barrier alarms. A seance was also held during the evening. The team found that cell two made some feel uneasy and there were strange smells. Orbs suddenly appeared during a vigil and were captured on camera. The presence of a man and young boy was felt by two mediums, whilst one participant felt chest and throat pressure. During the seance one member felt as if she had been beaten, particularly around her back and kidneys while another medium felt the labour pains of a young woman who died here in childbirth.

## Buccleuch Street Prison, Dumfries

This was the site of public executions in its day, so you might expect regular reports of strange sounds and sights here. Jamie McCallum told me, 'Walking past there one evening, I felt the atmosphere around me grow heavy. I am sure I heard heavy breathing coming from alongside, yet there was no one visible. It was really scary!' Ann Morris, who worked in the bank which was built on the site, said she often experienced 'weird' things and put it down to the fact that remains of the executed were unearthed when the bank was built.

# Pittenweem Tolbooth, Fife

Locals accused of being witches in the seventeenth and eighteenth centuries were locked up in here. It was a terrible place where they were tortured, tried and usually sentenced to death by burning. No wonder a huge amount of paranormal activity has been reported while ghost hunters claim to have captured footage of several of the supernatural beings that swarm around the building.

One story concerns a woman called Beatrix Lang who lived in the early 1700s. She asked the blacksmith's apprentice, Patrick Morton, to make some nails for her. He told her that he was busy but would make them later. Beatrix replied with something unintelligible and the boy thought she had cursed him. A few days later he became ill and spoke to Patrick Cowper, the local minister. Cowper egged the boy on to say that Beatrix was a witch but he obviously wasn't a very nice minister because he also gave the boy the names of several other locals who he claimed were also practising the black arts.

Well, it wasn't long after that these folks were imprisoned in the tolbooth and tortured. One of them, Thomas Brown, starved to death in his cell. Beatrix Lang was lucky compared to some because they let her go with a fine. She was chased out of the village though and died not long after in St Andrews. But once a witch-hunt starts, it's really hard to stop it. A lady called Janet Cornfoot escaped from the tolbooth but the villagers caught her and she was taken forcibly to the beach by her neighbours where she was beaten, pelted with stones and laid on the ground with a door placed on top of her. The villages piled boulders on top of the door until she was squashed to death. Even then they didn't leave her alone and drove a horse and carriage backwards and forwards across her body. Nightmarish.

Yes, the days of the witch-hunts were awful. The last person to be executed in Scotland for witchcraft in 1727 was Janet Horne of Dornoch.

Witches were sentenced to death in Pittenweem Tolbooth. (© L Moyse)

# Jedburgh Castle Jail and Museum, Scottish Borders

This Victorian jail with a bloody history was built on the site of a twelfth-century fort. It is the scene of frequent paranormal experiences; extreme poltergeist activity and ghostly apparitions are an almost constant occurrence.

On overnight ghost hunts the former exercise yard has proved to be very active with the distinct sound of bagpipes, possibly an echo from the past as the jail was once a castle with many skirmishes fought against English invaders.

The location was investigated by television's *Most Haunted* team. One restless spirit is said to be Edwin McArthur, a former prisoner executed in 1855. In death, he has even threatened members of the public. It's probably better if you don't see him. Less harrowing is the sight of the ghostly piper who stands on the battlements.

**A Ghostly Snippet:** Animals and children are more likely to 'see' a ghost.

You might hear bagpipes
being played here.
(© Gilly Pickup)

CHAPTER SIX

# Out in the Open

Ah, you think you're safer in the open air, in the mountains, glens and moorlands, surrounded by heather, birdsong and trees? Read on. You may just change your mind.

## Ben MacDhui, Cairngorm Mountains

In the Highlands of Scotland an aura of mystery and a sense of lurking menace from another era can still be found if you know where to look.

Strange noises echo from the among the rocks. Wraith-like shapes twist and writhe in the mist, leaving you with the unnerving certainty that you are not alone in the remote mountain pass. Is it imagination, or are there really steady footsteps crunching the scree somewhere unseen? Sheer terror grips your very being and you realise there is something right behind you …

For more than 200 years mountain climbers have reported eerie happenings in the Cairngorm Mountains. Could it all be down to Am Fear Liath Mor, the elusive Big Grey Man of Ben MacDhui? It's certainly more than just Scotch mist.

Cairngorms Carn Eilrig peak and Gleann Einich. (© Visit Britain and Joe Cornish)

Scotland's second highest mountain, Ben MacDhui is an ideal example of where strange creatures and equally strange sensations have been seen or felt.

The Big Grey Man of Ben MacDhui is said to be 10 feet tall and has been compared to the Abominable Snowman. He lurks in mists on magnificent Ben MacDhui, which rises to over 4,000 feet above sea level with a naturally formed cairn at its summit. His presence gives this mountain the distinction of being Britain's only haunted mountain.

The first reported sighting was in 1890, although the huge figure of the Big Grey Man has been reported striding over the mountain many times since. Some say that he drags chains behind him while others are adamant that the footprints he leaves are at least five times the size of any man's.

While it may be easy to dismiss these reports as hoaxes, there have been climbers of world renown who have been adamant that they heard sounds like someone, or something, was stalking them on the slopes. Most of them also reported feelings of dread, causing them to panic and so making them try to hurry down the slopes away from whatever might happen to be lurking in the mist.

In 1890, Professor Norman Collie of London University and a Fellow of the Royal Society was descending alone from the summit of the mountain when he became aware of footsteps following him. Although a highly respected scholar, he had no hesitation in making public his experience. He said, 'I was seized with terror and took to my heels, staggering blindly among the boulders for at least four or five miles until I approached Rothiemurchus Forest.'

Dr Kellas, a Scottish mountaineer who died on the Everest expedition of 1921–22, had a similar experience. He told of when he and his brother had been chipping for crystals on Ben MacDhui. Sensing some form of presence near them, they looked up to see a giant figure bearing down upon them from the summit. Convinced they were being stalked by a 'giant', both fled in panic down the mountainside, just as Professor Collie had done some years earlier.

One climber who claimed the Big Grey Man is fact, not fiction, experimented by measuring the height of the figure by geometry. He recorded the distance from the summit cairn of the vision's head, then measured it with his ice-axe making a visual comparison between the length of the ice-axe and the height of the horizon. His conclusion was that he had no doubt that the creature is over 10 feet tall.

Perhaps it is not too surprising that these reports by level-headed people about eerie happenings on the slopes of Ben MacDhui have served to stimulate the imaginations of those upon the fringes of society. One group of 'seekers' assert a 'Great White Brotherhood' live below the mountain in a huge dome-like building, whilst another claims it is an earth base for visitors from outer space.

However ridiculous some reports are, there is no denying that an air of mystery surrounds the mountain. Does this most majestic of mountains really harbour within its swirling mists a mysterious creature? Certainly, it's very slopes seem to have the effect of changing to an alien strangeness which some people claim has affected them mentally as well as physically. Even on bright summer days when the mountain is free of mist, some climbers have found themselves suddenly gripped by fearful thoughts and sensations as they rest to admire the views. There have been reports of loud, sonorous voices speaking Gaelic, music which seems to emanate from the rocks and, in extreme cases, a feeling of evil emanating from certain areas on the slopes.

So, is the Big Grey Man of the same genre as the Yeti or Abominable Snowman? The Yeti is documented as being one, or several, mysterious creatures who inhabit forests

Climbers have encountered the Big Grey Man. (© Gilly Pickup)

and plains in Siberia, China and part of the Himalayas, believed by some scientists to be surviving ancestors of our own species. Again, of course, until specimens are caught, alive or dead, there will be no proof.

Cynics dispel the notion of a Yeti-like creature on Ben MacDhui by putting forward such theories as distortion caused by atmospheric changes, wind howling through the crannies, or simply the effect of rocks expanding and contracting due to temperature changes. Sightings are more difficult to explain away, though the effects of whirling snow, the odd tree or even other climbers have all been put forward by those who find the idea of a gigantic phantom impossible to accept.

Could there be a more acceptable explanation for the phenomenon? It could be the optical illusion known as the Spectre of the Brocken, first recorded years ago in the Harz Mountains of northern Germany. The effect is said to occur when a climber is standing in a place where the ground falls steeply in front of him, generally on a ridge or clifftop. The low angle of the sun casts the observer's shadow onto an opaque mist wall, which results in the terrifyingly tall image of a grey-coloured figure. Some experienced climbers say that Brocken Spectres are not really that rare. For those who are on the hills around two weekends a month, some say they might expect a sighting two to three times a year.

Could the Big Grey Man be a ghost? Some mountaineers believe that he is the spirit of a dead climber, though that does not explain why he is so tall.

Brocken Spectre? Yeti-type creature? Ghost? Effects of imaginations enhanced by isolation, dangerous conditions or bad weather? Though these may well explain away some of the many sightings, it is hard to believe that experienced climbers who

have seen the lonely shadow of the Big Grey Man insist that what they have seen is anything but fact. Certainly, the eminent Professor Norman Collie felt that his one encounter with the enigma was quite enough. 'There is something very strange about Ben MacDhui,' he said. 'I know I will not go back there again by myself.'

## Culloden Moor, Inverness

This beautiful, bleak, bare and windswept moor near Inverness is where Bonnie Prince Charlie's rebel army of 5,000 comprised of Scottish clans including the Stewarts, Macdonalds and Frasers was defeated on 16 April 1746 by the Duke of Cumberland's government troops numbering over 9,000. This was one of the most harrowing battles ever fought on British soil and marked the end of the Jacobite rebellion.

Cairns proudly stand where the Scottish men bravely died in the battle. On the anniversary of the battle visitors have reported seeing bloodstained ghostly figures and hearing cries, sword clashes and gunfire. Apparitions of men fighting for their lives is commonly reported. The most poignant spectral appearance is that of a tartan-clad Highlander lying terminally wounded who murmurs the word 'defeated'. An interesting tale from a few years ago concerns a woman visitor who happened to look into the Well of the Dead. What she saw frightened the life out of her because looking up at her from the depths of the well was a Highlander covered in blood. She felt an innate sadness as she looked into the poor man's eyes. He has been seen here several times and is thought to be Alexander MacGillvary, leader of Clan Chattan regiment who died here. Someone else who visited the battlefield found a piece of Stewart tartan and at the same time saw in the distance a Highlander dressed in the same tartan lying on the ground.

Tartan from Culloden. (© Gilly Pickup)

# Glencoe, Highlands

On 13 February 1692, the brutal Glencoe Massacre took place, another of the bloody incidents in Scotland's history. A troop of soldiers acting on government orders posed as friendly visitors before attacking their hosts, the Macdonald of Glencoe clan,

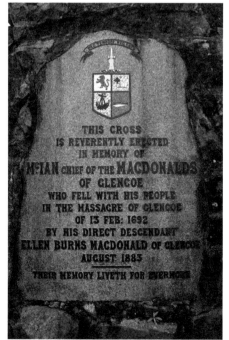

*Above*: Chilling site of the Glencoe massacre. (© Gilly Pickup)

*Left*: Memorial in Glencoe Village. (© Gilly Pickup)

*Below*: Blood-curdling screams have been heard in the glen. (© Gilly Pickup)

while they lay sleeping in their beds. Thirty-eight men, women and children were murdered. Other members of Clan Macdonald fled to the surrounding mountains, but died of exposure in the bitterly cold landscape.

Nowadays people claim to have seen re-enactments of the slaughter or have heard blood-curdling screams in the glen. These occurrences take place in the winter months, particularly around the anniversary of the massacre.

## Den o' Mains, near Mains Castle, Dundee

Popular with dog-walkers during the day but if you're thinking of taking a shortcut across the park at night, it might be wise to think again because you never know who you might meet along the way. There is a witness report from the 1960s and again in the 1980s from people out walking just as dusk fell who saw a Victorian gentleman and woman pushing a pram. They described the clothes clearly, heard the wheels of the pram as it scrunched across the gravel. They said that they were so close they could have touched them but just like that, right before their eyes, the Victorian couple vanished.

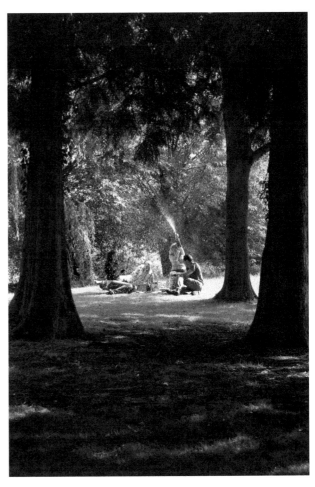

Lovely in daytime but you could meet a ghostly Victorian couple – if you're lucky.
(© Gilly Pickup)

Den o' Mains as dusk falls. (© Gilly Pickup)

## Bell Street Car Park, Dundee

This car park was built on the site of a prison and its cemetery, which is where the creepy stories probably come from. People going into the car park at night to collect their cars have stopped in their tracks because of sounds of heartbreaking wailing. On investigating, no one seems to be there. The body of one William Bury lies beneath the concrete here. He was suspected of being Jack the Ripper, probably because he once lived in London's Whitechapel and was rather a nasty piece of work who murdered his wife then cut her into pieces. The Ripper murders stopped after he moved to Dundee, but that's possibly just a coincidence. In 1889 he was hanged for his wife's murder and has a dubious claim to fame as the last person to be hanged in Dundee.

## Killiecrankie, Perthshire

On 27 July 1689 the peace and tranquillity of this beautiful gorge was shattered when the first shots in the Jacobite cause were fired. One soldier escaped by making a spectacular jump across the River Garry at the spot now known as Soldier's Leap. On the anniversary of the battle, the Pass of Killiecrankie is said to ring with the sound of footsteps as the government army march to their doom. Other accounts describe terrifying encounters with a gruesome floating head.

Killiecrankie, where the first shots in the Jacobite cause were fired. (© Gilly Pickup)

# Greenbank Garden, Glasgow

With several resident ghosts, this wonderful garden oasis is both idyllic and mystical. Look out for the Lady in Red; she also makes occasional appearances indoors, especially in the dining room of Greenbank House. There's a large black phantom

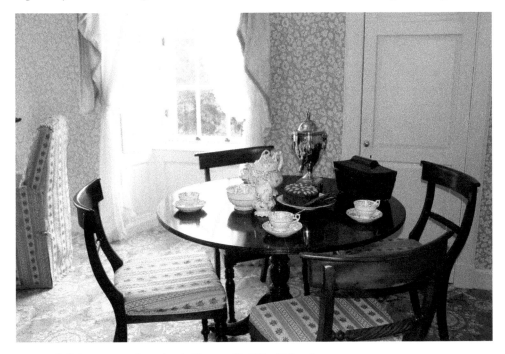

Haunted dining room, Greenbank House. (© Gilly Pickup)

dog too, which may go racing past you as if wanting you to join it in a game. A little girl regularly plays with a skipping rope beside the burn. Although at first glance she looks real, she is the ghost of a local girl killed in the courtyard in the early twentieth century.

## Burns National Heritage Park, Alloway, Ayrshire

Our much-loved national bard Robert Burns was born in a wee cottage in Alloway on 25 January 1759, a date well remembered by Scots everywhere and celebrated worldwide with Burns suppers. As a boy he liked to listen to stories about ghosts and witches. One of the poems he wrote called 'Tam o' Shanter' drew on these childhood memories. Tam disturbed a witches' coven dancing in the local kirk, no less, late one night. He had to flee for his life, the witches chasing him until he crossed the auld Brig o' Doon. Of course, witches can't cross water but they made a determined last effort to stop Tam by pulling off his horse's tail. Just a story, thank goodness! Some have said though, that on dark, rainy nights, horses' hooves are heard clattering across the humpback bridge.

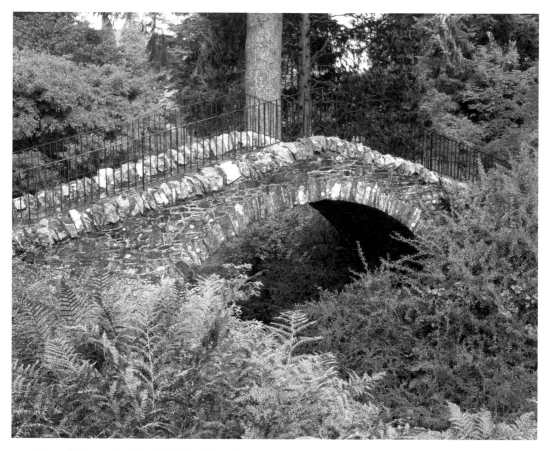

Tam o' Shanter bridge. (© Gilly Pickup)

# Aberfoyle, Perthshire

And this is indeed a strange tale of a minister and the fairies …

In 1691, Robert Kirk, a clergyman, wrote a book called *The Secret Commonwealth of Elves, Fauns and Fairies*. In this remarkable book he describes fully the nature of Fairyland, the Celtic Otherworld, as a very real place, with its own laws and a hierarchical order of inhabitants, who he describes as, 'intelligent studious Spirits and light changeable bodies, like those called Astral, somewhat of the nature of a condensed cloud, and best seen in twilight'.

It is said to be from this 'Secret Commonwealth' that seers receive their communication in the form of visions or signs. According to Kirk, it is even possible for mortals to journey there. However, there is always a danger that the people concerned might not be able to return to this world, which is said to have been the fate of Kirk himself.

Robert Kirk was born in the manse in Aberfoyle in that beautiful area of Central Scotland, the Trossachs. He was the gifted seventh son of a seventh son, his father being the local minister, the Revd James Kirk.

As a boy, he moved with his family to the neighbouring village of Balquidder and became a student of theology at St Andrews University. He was a noted scholar, translating the Scottish metrical psalms into Gaelic and was also involved in preparing a Gaelic translation of the Bible.

He was appointed to the ministry in Balquidder in 1664 where he served for twenty years. In 1685, he was called to Aberfoyle to preach in his father's old kirk, so with his second wife and family moved back into the manse where he was born.

In 1689 he wrote that those who possessed the faculty of Second Sight were thought to have received the ability from dead ancestors who inhabited mounds and knolls near churches. He is quite matter-of-fact in his writings that people with Second Sight are able to see fairies, though the fairies are invisible to all others.

Those seers who had the ability to witness such sights regarded it as an affliction rather than a gift. Kirk wrote that the inhabitants live in houses underground that are 'large and fair, lit with lamps and fires but without fuel to sustain them'. He says that they may abduct mortal women to nurse their children and that their clothing and speech is that of the country they live in. Their lifespan is longer than ours, but eventually they die. They have rulers and laws but no discernible religion. Moreover, unlike mortals, they do not have a dense, material form, but have, in Kirk's words, 'bodies of congealed air'. He says that sometimes they 'grovel in different shapes'.

He writes that they feed on 'corn and liquors' and every quarter they travel to fresh lodgings, a reference perhaps to the elemental tides of the seasons. From his writing we can tell that these are not the tinselled fairies of Victorian times but wild and elemental spirits of nature.

He explains that the drudges among faeries, called brownies, often perform services for families and farmers, usually without their knowledge.

Two passages in the book deal with methods of gaining the Second Sight. One describes how a 'curious person' can be temporarily imbued with the Sight, with the help of an experienced seer: 'The usual method for a curious person to get a transient Sight of this otherwise invisible crew of Subterraneans … is to put his left foot under the seer's right foot and the seer's hand is put on the inquirer's head, who is to look

A fairy – best seen in twilight. (© L. Moyse)

Aberfoyle in the Trossachs. (© Gilly Pickup)

over the wizard's right shoulder ... then he will see a multitude of Wights, like furious hardie Men, flocking to him, hastily from all Quarters, as thick as Atoms in the Air.'

So, were the contents of *The Secret Commonwealth* the result of this clergyman's first-hand knowledge? It may have been that Kirk employed seers to give him information about the dark and silent world, just as Dr Dee relied upon Edward Kelly a century before, while others believe that the depth of information could only have been gleaned by his own discovery.

Legend says that in publishing the book, the Revd Kirk broke the taboo of secrecy that the Sidhe impose on those mortals they have communicated with. Shortly after its publication, he collapsed and died on top of the Fairy Hill one day while out walking. His body was buried in Aberfoyle churchyard and a gravestone marked his resting place. However, it was believed by all who knew him that in fact Kirk did not die at all, but was kidnapped by the inhabitants of the Otherworld and the body which was buried was a replica left by the fairies to avoid suspicion and satisfy his human friends and loved ones. He was around fifty-one when he disappeared and his tomb was inscribed: 'ROBERTUS KIRK, A.M. Linguae Hiberniae Lume'.

His form was seen by a relative. Scott's *Demonology and Witchcraft* published in 1830 says, 'The form of the Rev Robert Kirk appeared to a relation and commanded him to go to Grahame of Duchray. Say to Duchray, who is my cousin, as well as your own, that I am not dead, but a captive in Fairyland and only one chance remains for my liberation. When the posthumous child, of which my wife has been delivered since my disappearance, shall be brought to baptism, I will appear in the room, when,

if Duchray shall throw above my head the knife or dirk, which he holds in his hand, I may be restored to society; but if this is neglected, I am lost for ever.'

Sure enough, the birth and the christening came. Grahame of Duchray was there, just as he had been bidden. During the ceremony the outline of the former minister could be seen clearly but Duchray was so astonished that he failed to throw the dirk. Immediately following that occurrence, the author of the Secret Commonwealth disappeared, never to be seen again.

To this day the question remains, did he die or was he 'taken'? It would seem that only the elusive folk who live under the earth in the green hills can answer that.

Footnote: It is perhaps interesting to note that Sir Arthur Conan Doyle, also a profound believer, described the fairy race as real, 'a population which may be as human as the human race but which pursues its own strange life in its own strange way'.

**A Ghostly Snippet:** Not all ghosts are 'trapped'. Some choose to stay within the earthly realm.

CHAPTER SEVEN

# Seafaring Spooks

It is to be expected that Scotland, a seafaring land, has no end of ghostly tales about sea monsters, mermaids, ships and haunted beaches too. Here are stories about some of them.

## Loch Ness Monster, Inverness-shire

Ten thousand years ago the last remaining Ice Age glaciers carved a vast 24-mile crevice in the Scottish Highlands. As the ice melted, the crevice filled with water and became known as Loch Ness, home of one of the most mysterious, best-loved phenomena in the world.

Could the area surrounding Loch Ness be a potent psychic energy centre, as some believe? Is the monster a survivor from another millennium? Is it a phenomenon created though the mind power of witnesses? Or is it an inhabitant from another dimension or plane of existence which emerges from time to time into our world?

Loch Ness – home to a mysterious monster. (© Visit Britain and Andrew Picket)

An unsolved mystery lies in this loch. (© Gilly Pickup)

Among thousands of reported sightings and investigations, the creature has been described as anything from 15 to 40 feet long with one or several humps. Scientists speculate that should she – Nessie is always referred to as female – exist, she could be a prehistoric marine reptile with a long neck and flippers while others believe she could be part of the eel family. Parts of Loch Ness are deeper than the North Sea and its vastness and remoteness could have allowed the creatures to flourish undisturbed as survivors from another millennium.

It was St Columba who made the first recorded sighting in AD 565 when he was travelling to Inverness on a mission to bring Christianity to the Scottish tribes. Since those far-off times, there have been many reported sightings but she still remains an enigma.

Nessie the Loch Ness Monster is one of the world's most enduring mysteries.

## The Benbecula Mermaid, Outer Hebrides

The island's Gaelic name, Beinn na Faoghla, translates as 'the mountain of the fords' and some say there is a mermaid's grave here, though the exact spot is unknown. In the nineteenth century local women were cutting seaweed while their children played on the shore. They noticed something that looked like a mermaid in the sea. Excitedly the children started throwing stones at it (that wasn't very nice, was it?) and the mermaid vanished. A few days later near Cula Bay a body was washed ashore.

Mermaids and mystical sea creatures abound in Scotland. (© Gilly Pickup)

Reports at the time said that the upper part of the creature was the size of a child and the bottom half had a fishlike tail. A church minister came and the body was taken to Nunton, where it was recorded as a mermaid. She was wrapped in a cloth and given a burial. Folklore says that this was one of the largest funerals the island had seen, which indicated that those who identified the body believed that it was human-like enough to have a burial.

## Sandwood Bay, near Cape Wrath, Sutherland

Although one of Scotland's most beautiful beaches, the waters off the coast of Sandwood Bay are treacherous and serve as a graveyard for many an unfortunate ship. Before the lighthouse at Cape Wrath was built in 1828, a host of poor souls lost their lives here, which probably explains the many ghostly sightings of sailors trying to reach the shore. If you happen to see an old sailor dressed in a tunic with shiny brass buttons and sea boots which are worn and torn, try not to be too alarmed; many others before you have seen him.

## Flannan Isles, Outer Hebrides

Lying 20 miles off the west coast of Lewis, the Flannan Isles archipelago is famed for its unexplained disappearances. Three lighthouse keepers vanished from the isolated lighthouse in 1900. After reports from passing ships that the light was not operational, the vessel *Hesperus* was sent to the island to see what the problem was. It was found that the last recorded entry in the diary was 15 December, eleven days before the *Hesperus* arrived, but there was no sign of the three men, James Ducat, Thomas Marshall and Donald McArthur. What happened? No one knows. More than a century later the fate of the lighthouse keepers remains one of Scotland's enduring mysteries. The incident was the inspiration for an episode of *Doctor Who* which was set in a lighthouse and involved an alien explanation for the mystery.

## Callanish Standing Stones, Isle of Lewis, Outer Hebrides

This is a fantastic stone circle, a unique setting of megaliths second only in importance to Stonehenge. Dating back to around 3000 BC, these nineteen monoliths make up a circle of thirteen stones with more stones reaching to south, east and west. There have been countless suggestions put forward as to why these stones were put there – was it to deter evil spirits or was it, as some suggest, charged with bioelectric potential by rings of dancers so acting as a navigational beacon for UFOs which visited the Earth? It is unlikely that we will ever know.

Standing stones lend a mysterious feel to the landscape. (© Gilly Pickup)

# HMS *Unicorn*, Dundee

Shadows, cold spots and apparitions, they have all been reported by some of those who have boarded this ship which is now used as a museum. Visitors have many a strange tale after coming here and some say that they have had the uncomfortable feeling of being watched when no one else is there. Some get their hands held, heads touched and may get pushed or prodded. Mary B, who lives in Tealing outside Dundee, told me that she paid a visit to the museum ship with her family. 'I had heard tales of ghosts and odd things happening there, but thought it was all rubbish. However, on the day that we visited, my youngest daughter Janie – she was seven at the time – suddenly started to cry. When I asked her what was wrong, she said to me, "that man over there, he keeps staring at me." There was no man there that we could see. Next thing was though, I felt someone push me in the back and could swear to God that I heard a man's deep voice saying, "this is my vessel – you're tramping round my vessel, interrupting my work. I need to get on with it." Well we didn't linger after that and now of course I don't disbelieve anyone who has strange stories to tell about Unicorn!'

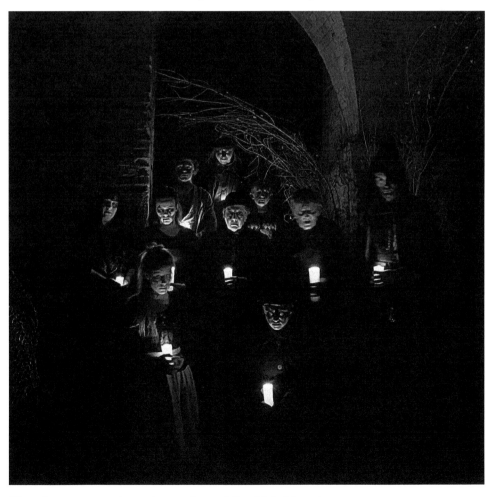

Ghost hunts are popular with some brave folks. (© L. Moyse)

There have been so many strange happenings in fact, the ship has attracted paranormal investigation teams who uncovered a spectre. They called him George, after George Bishop who was once the vessel's custodian. Television's *Most Haunted* sent along a film crew and team of experts and they recorded a high level of abnormal activity. It seems it's not only George but several phantoms who live on board. That's enough to shiver your timbers and then some.

## The Piper's Cave, near Stranraer, Argyllshire

The faint sound of bagpipes can sometimes be heard issuing from a cave mouth on the jagged coastline at Clanyard Bay near Stranraer. If you hear it, don't be afraid; it is only the phantom piper and he won't harm you. In life, the piper is said to have invoked the fury of the fairies, who were the cave residents, because he entered with his loyal dog and played his pipes in their domain. He could play the most wonderful tunes, almost like a pied piper. The lilt of the notes captured the soul of those who listened to him. Some people said he was the only man to escape the Dunaverty massacre and, with his little dog, played for money to buy food. But the strangest thing happened, because after the sound of his pipes had faded away, only his dog ran out alive. A farmer tending his sheep saw the little dog appear from an opening. As the farmer listened, he heard far in the depths the wail of the pipes, haunting notes of Scotland's sad history. He took the dog home and cared for it and when it died, he buried it near the opening where it had appeared to him many years before. What happened to the piper? No one seems to know.

**A Ghostly Snippet:** Spirits retain their personalities and can be helpful.

You could hear a piper playing laments when you visit the cave. (© Gilly Pickup)

# Theatres – Yes Folks It's Showtime!

Audience participation – and I wonder, does the resident phantom join in? (© Gilly Pickup)

What is it about theatres that attracts spectral activity? Theatres, like pubs, where lots of people gather over a number of years, often have a much higher than usual level of ectoplasm, built up over time, which enables spirits to materialise, be seen and sometimes heard. Supernatural doings are par for the course on stage. That is of course, only for those who believe in such things ...

## Theatre Royal, Glasgow

You have to feel loads of sympathy for poor Nora who desperately wanted to be an actress. But either her acting was truly abysmal or the selection panel were particularly obnoxious, because Nora was booed offstage at Glasgow's Theatre Royal after a disastrous audition and promptly took her own life. She cocked a snook at those judges though because her continued presence ensures she'll last longer on stage than any of her former contemporaries.

# Festival Theatre, Edinburgh

Edinburgh's Festival Theatre is supposedly one of Scotland's most haunted. There are tons of ghosts here. Over the years, staff have reported no end of strange things, from cold spots and doors that open and close by themselves to spooky sights in the basement.

One of the strangest stories concerns the Great Lafayette – his real name was Sigmund Neuberger and he was one of the most celebrated illusionists of the early twentieth century. His illusions and elaborate quick changes made him the highest-paid entertainer in the theatre of the time. In 1911, he visited the Festival Theatre, which was then called the Empire Palace Theatre, to perform his most ambitious production to date. However, inexplicably as he was performing a lamp toppled over and set the stage on fire. Several people died including the great man himself, who was later found under a trapdoor in the basement beneath the stage. Even though he is now long gone from this earth, he still comes back to the theatre, continuing to mystify those who see him.

There's a one-legged sailor too, called – rather unimaginatively, it has to be said – 'peg leg'. Long ago off-duty sailors were hired to run the fly loft because they knew all about knots and how to raise and lower sails. The narrow platforms, dimly lit during performances, can be daunting places. High above the stage on the narrow walkways of the fly floor there have been sightings of a figure who limps as he paces up and down while the creepy sounds of an artificial leg scraping on the floor have been heard coming from the empty fly floor.

Stage door. (© Mike Pickup)

The upper circle has a pretty ghost, that of a little girl who wears a yellow dress. She likes to play games between the seats when no customers are sitting there. Sometimes though, if she is feeling a bit naughty, she creeps up behind those sitting there and gently pulls their hair or blows softly on the back of their neck. She is not frightening, so don't worry if you visit and feel her presence.

One actress told me that she has felt on occasion that someone has followed her onto the stage, but this is someone she couldn't see. Ohers have whispered of seeing glowing apparitions.

Well, you know what they say: mortals live until they die, but ghosts hang around long afterwards …

## Theatre Royal, Dumfries

In Scotland's oldest working theatre many of the paranormal happenings occur in the Green Room. Among those who have thrilled audiences here are J. M. Barrie, he of *Peter Pan* fame, John Laurie and Scotland's greatest poet Robbie Burns. though it is not recorded whether they saw, heard or felt anything spooky.

A Green Lady, particularly active in the 1970s and 1980s, still sometimes makes her presence felt to unsuspecting guests while at other times the sweet sound of opera

You could see a lot more than you bargained for when you visit the theatre. (© L. Brand)

singing has been heard. Then there is the woman who fell from the balcony, killing herself. When the theatre is almost empty, she rises slowly from the floor, wringing her hands in grief. There is a staircase – I'm not saying which, you'll have to find out for yourselves – which is particularly eerie. Those people who use it suddenly feel as if there is a presence walking right alongside them … Do please let me know if this happens to you.

## Playhouse, Edinburgh

Albert, who wears a grey coat, tends to appear at night on level six accompanied by a chill in the air. In life he may have been a stagehand or nightwatchman – no one seems to know for sure – and the old brick building that he haunts was once a cinema. Before that it was a tabernacle – a religious meeting site – and it even served as an insane asylum run by nuns. Back further still, the land was a jousting ground in medieval times. Quite a history.

However, Albert wasn't around back then it seems; he first appeared in the 1950s when the building was a busy cinema. One day, after a reported break-in the night before, police arrived to speak to the manager about it. One policeman, making an inspection of the building, returned to the manager's office to say that he'd met a man in grey overalls who had introduced himself as Albert the doorman. The nonplussed manager said there was no one else in the building and there was no Albert the doorman working there.

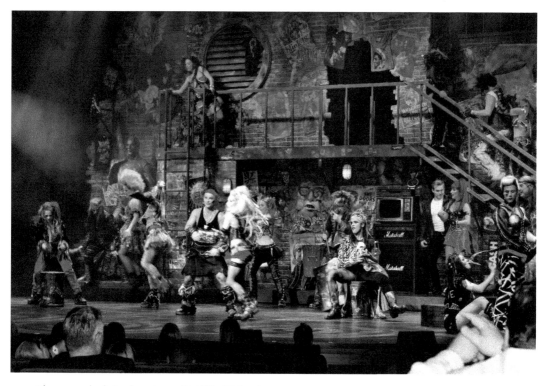

Phantoms lurk in the wings. (© Gilly Pickup)

That wasn't the only time that Albert was to spook the boys in blue. When police checked the building in 2005 before the G8 summit, they couldn't understand why the sniffer dogs wouldn't enter level six. Someone decided that it must be Albert's presence which was off-putting for the dogs. The police borrowed dogs from the castle – these were canines who were apparently used to all sorts of spooky presences and did check out level six.

Since then though staff who work in the building have sometimes reported strange occurrences such as footsteps when no one is around and doors slamming when no one else is there. One staff member even reported hearing an orchestra playing late at night. Besides all that, many have told stories about spotting a shadowy grey figure lurking around a room on level six. It seems that Albert enjoys staying in the theatre, and staff have learned not to mess with the spook. Once when workmen were repairing something on the stage they were playing heavy metal very loudly on a tape deck. The music stopped all of a sudden and the next thing they knew was that the cassette flew across the stage. Obviously the music wasn't to Albert's taste.

The theatre bar is called Albert's Bar. There is no mention of Albert being seen in there though, so maybe he didn't drink.

**A Ghostly Snippet:** Children under the age of five are most likely to see a spectre.

CHAPTER NINE

# Miscellaneous

The tales in this section cover different subjects and do not easily fit into any other part of this book, so I have gathered them together here.

## Rosslyn, Midlothian

Rosslyn's phantom ghost dog is said to have been a war hound that was slain at the Battle of Roslin in 1303. After the battle, the ghostly apparition of the huge dog was seen by resident soldiers and the man who killed the dog's owner died of terror within days. Nowadays, people sometimes speak of hearing a ghostly howling echoing from the woods that surround Rosslyn Castle's ruins.

## The Real Mary King's Close, Edinburgh

Beneath the City Chambers on Edinburgh's Royal Mile is the city's deepest secret: a warren of hidden closes (in Scotland a 'close' is a street) where people lived, worked and died between the seventeenth and nineteenth centuries. These closes would have been extremely narrow walkways with houses on either side reaching up to seven

Mary King's Close in Edinburgh. (© Mary King's Close)

Will you see something out
of this world in Mary King's
Close? (© Mary King's Close)

storeys high. In 1753 the authorities decided to build the Royal Exchange, which is now the City Chambers. Houses at the top of the close were demolished and part of the lower sections were used as foundations for the new building. This left numerous enigmatic underground closes and ancient buildings steeped in mystery.

This area is said to be awash with ghosts. In 1992 psychics identified a 'cold spot' in a room in one of the old houses. Later, a Japanese spirit medium saw an apparition there – a little girl called Annie. The psychic said that Annie was upset because she had lost her doll, so she bought her a new one. Since then, many people claim to have felt Annie's presence and some leave toys in what has become known as the Shrine Room while others leave money, which is donated to a children's hospital. Other phantoms live here besides Annie and there have been reports of scratching noises coming from inside a chimney where a sweep died and sometimes people who have put their hands in the chimney have felt them being touched. Dare you …

## George Street, Edinburgh

In 1945 or thereabouts, a man called Donald Gray was walking along George Street when he became aware of a lady dressed in clothes fashionable at the turn of the century. He noticed that her complexion was startlingly white. As she came closer

A phantom woman was seen on this street. (© Gilly Pickup)

to him he felt a chill run through his body. That was when he felt sheer horror – he was looking at a corpse's face. What struck him as even stranger was although the street was busy with people going about their business, no one else paid the slightest attention to the woman. Intrigued, he decided to turn round and follow the woman as she headed for a chemist's shop. She opened the door and went inside and he made to follow her. It was astonishing – she wasn't there! He thought he was going mad, so went up to the counter to ask the assistant where the lady had gone. 'No one came in here,' he was told.

A few days after that, Donald was back in George Street. There was a sudden unexpected downpour, so he went into a café for shelter. There, seated at a table, wearing the same outfit he had seen her in a few days previously, was the phantom. When she left the café he followed here again and saw her head for the chemist's shop.

He decided to look into the history of the shop and discovered that some years previously the shop belonged to a Mrs Bosworth who ran a dressmaker's business. She in turn had bought the business from a woman called Jane Vernelt. However, after Mrs Bosworth was running the business, she kept getting visits from Miss Vernelt who despairingly said she had made a mistake in selling the business and that she should have kept it. She begged Mrs Bosworth to sell it back to her, but Mrs Bosworth wasn't interested. She was making a good living from it and wanted to keep it. Miss Vernelt grew more and more agitated and eventually went mad and died. She started to haunt the shop, gliding around as if she still owned it.

Although Mr Gray returned to George Street after that, he never again saw the ghostly lady. Perhaps because he took the time to look into the case and find out about her, it finally laid her spirit to rest.

# Bonnybridge, Stirling

Is Bonnybridge a portal to another dimension? The town lies at the heart of an area known to UFO enthusiasts as the Falkirk triangle. There have been more than 600 UFO sightings over the years with descriptions varying from 'large blue lights the size of a basketball sitting on a road'; 'a big truck thing, like a huge Tonka toy came out of the trees and something flashed, as if we'd been photographed'; and 'a black, circular object with a row of green lights came out of the sky'. In one instance someone filmed one of the objects. There were six witnesses to this and all of them were certain it was not a regular aircraft. Many people have reported sightings of a quiet object that can hover and change direction suddenly. No known aeroplane fits that pattern. A UFO lecturer suggested that Bonnybridge is a 'thin place' where this world is close to another dimension. The answer remains a mystery.

# Edinburgh

Most people have heard of Greyfriars Kirk and the heartbreaking story of the little Skye terrier 'Greyfriars Bobby' who wouldn't leave his master's grave. Many come here to see the statue of the little dog and also come to visit Thomas Riddell's grave – he was the one who gave his name to nasty Dark Lord Voldemort in the Harry Potter books.

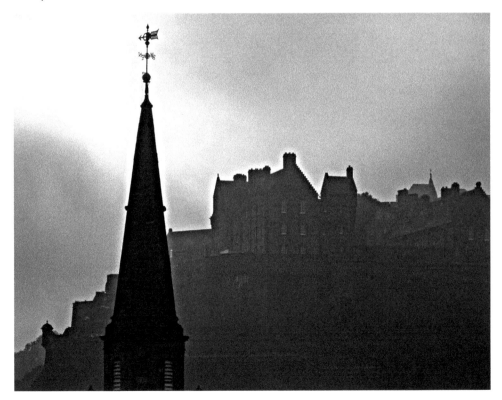

Edinburgh is a spooky city. (© Gilly Pickup)

There is more than that here though and behind Greyfriars Kirkyard is a building called the Black Mausoleum, a terrifying structure and the resting place – perhaps not an apt description here – of Sir George Mackenzie. A former Lord Advocate, he returned after death as a particularly nasty poltergeist. In life he condemned hundreds of Covenanters to death back in the 1600s earning him the nickname Bluidy Mackenzie. The Covenanters were buried close to Mackenzie's mausoleum.

This has been described as the 'scariest place on earth' and while no one can prove whether or not that is true, it is certainly apparent to many who come here that this is not only a seriously haunted place but one which has a bad vibe too.

On a stormy winter's night in 1998, a homeless man was looking for shelter. He broke the lock on the door of the Black Mausoleum and went in. Inside there were coffins belonging to some of Mackenzie's relatives. The story goes that the homeless man broke one open and as he did so the floor beneath him collapsed. He fell down into some kind of a pit which was full of plague victims. They had been there for hundreds of years. Well, not surprisingly he couldn't get out quickly enough and fled from the scene. The story got around and people were horrified that the dead should have been disturbed like this. Not long after that though, people who came to visit the kirkyard started to have problems. A woman was forcibly knocked to the ground by an unseen force. A man was found unconscious beside the mausoleum, his neck a mass of bruises which looked like someone had attempted to strangle him. People were terrified, so the city council sealed up the mausoleum with strong locks on the door. Do locks stop the force of spectres though? No way. Unexplained incidents continue regularly. People say they have been bitten, pushed, kicked and punched.

A dreaded poltergeist haunts here. (© L Moyse)

Some are physically sick. Others faint. One man's hands and arms were covered with what looked like cigarette burns. Those who know about such things are in no doubt – it's all down to George Mackenzie. In all there have been more than 500 recorded incidents of people being attacked by the poltergeist while others have blamed it for suspicious fires in nearby buildings. In 2000, a priest performed an exorcism in the kirkyard, to try to stop the trouble. He said afterwards that he was totally overwhelmed by the tormented souls of the dead and had to leave. Not long after, he sadly died. Visit at your peril – the fear factor for this one is frightful!

## Montrose, Angus

In May 1913, twenty-nine-year-old Lt Desmond Arthur climbed aboard BE2 No. 205 for a normal practice flight. At 7 a.m. the engine of his aircraft roared into life and he took to the air. Thirty minutes into the flight the machine was seen descending in a left-hand spiral before banking to the right. The right-hand wing was seen to collapse from tip towards fuselage. Spectators reported they heard the engine accelerating and saw smoke coming from the plane. The aircraft pitched downwards and Lt Arthur fell to his death, hitting the ground around 200 yards in front of Lunan Bay Station, just outside Montrose, my hometown.

An enquiry accused Lt Arthur of 'stunting' his machine and afterwards, his spectre was seen repeatedly at the Officers' Quarters. His name was cleared when the findings of the enquiry were overturned and he was exonerated from blame, the accident being due to a botched repair.

Montrose Rossie Braes near where Lt Arthur's flight crashed. (© Gilly Pickup)

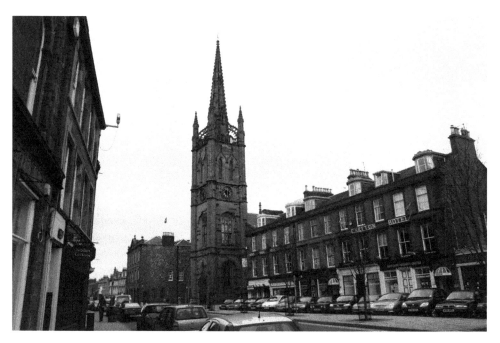

High Street Montrose – my hometown. (© Gilly Pickup)

Over the years, there have been numerous reports of sightings of Desmond in and around the aerodrome in Waldron Road on the town's outskirts.

It is a strange story but there is an even stranger tale connected to it. In 1963, pilot Sir Peter Masefield gave a stranger wearing a flying jacket a lift in his Chipmunk plane. They left Inverness en route for Edinburgh's Turnhouse airport. As they flew over Montrose airfield, Masefield was shocked to see an old plane suddenly appear from a break in the clouds. He could even see the pilot clearly and was mesmerised as he saw the plane fall out of the sky. At the same time his passenger issued a scream. Moments later, almost paralysed with shock, Masefield landed his plane at Montrose, but his passenger had vanished. No one at the aerodrome had seen anything unusual and no plane had fallen out of the sky. The incident occurred on 27 May, fifty years to the day after Lt Arthur's death.

So, here we are, almost at the end of this book. I hope you have enjoyed what you have read and please do let me know if you have any particular spooky places or have had any spectral encounters that you would like to tell me about. Now we have reached the last story, a sinister one. I would suggest you trim the candle, wrap up cosy and prepare to be scared. Don't forget these wise words: 'Behind every man now alive stand 30 ghosts, for that is the ratio by which the dead outnumber the living.' (*A Space Odyssey*, Arthur C. Clarke, 2001)

# West Bow, Edinburgh

Thomas Weir lived with his spinster sister Grizel in a gable-fronted house in the West Bow, a street near the castle. In Robert Chamber's book *Traditions of Edinburgh*, he described the street as being 'composed of tall antique houses with numerous

The Grassmarket haunted by Major Weir. (© Gilly Pickup)

dovecot-like gables projecting over the footway ... presenting at every few steps some darkest lateral profundity, into which the imagination wanders without hindrance or exhaustion'. Well, that's better than I could put it.

Weir was a pious Covenanter. Though people came from miles around to attend his inspirational prayer meetings, he refused to preach, saying that was the province of those specially ordained. However, he prayed with 'great liberty and melting', leaning on his blackthorn staff, which people would remark was almost like part of himself.

One day instead of delivering his usual eulogy, Weir announced in front of everyone gathered there that he was a servant of the Devil. The congregation were stunned. How could this pious man, known as 'Angelic Weir', possibly be involved in the black arts? Had he gone mad? The group tried to reason with him and suggested that he was ill. Assembled worshippers thought the best thing to do was to keep the whole unsavoury matter under wraps, at least for the time being.

Confessions to witchcraft were a common occurrence in Scotland in the sixteenth and seventeenth centuries, but were usually extracted from the victim by torture. It was bizarre for someone, particularly a person so highly regarded in the community, to provide a confession voluntarily.

Before long, the strange scenario had reached the ears of the authorities. At first the major's confession seemed so incredible that the provost, Sir Andrew Ramsay, chose to ignore it. How could he possibly take this pious man into custody? When Weir persisted,

the wild declarations were put down to him 'being of increasingly feeble mind'. The authorities felt it preferable to declare Weir insane instead of prosecuting him. Things went from bad to worse then though, and the major then revealed that he and his sister had been involved in an incestuous relationship for years. He also insisted that he was driven to heinous acts of black magic by the Devil. Grizel, meanwhile, willingly agreed with all her brother said.

Eventually magistrates called with a warrant at the Weirs' home. The house was searched and money found in various places, wrapped in rags. A bailie in charge of the search threw a piece of rag into the fire and was astonished to see that although it landed in the flames, it did not burn but instead exploded and flew straight up the chimney. He described it as being 'like a cannon'. That day, both Major Weir and Grizel were taken away to the gloomy old Tolbooth Jail. As they left the West Bow for the last time, Grizel screamed at the guards to seize Weir's blackthorn walking stick because it was a servant of the Devil and the source of her brother's power. Blackthorn, a sinister tree in folklore, has always been associated with witchcraft in Scotland. Cautiously handled, it was lodged in the Tolbooth as securely as its master.

The provost sent doctors to examine Weir but they agreed he was as sane as they were. His own sect paid visits to him too and a certainty gained ground that his confessions were substantially true.

In prison, the major was advised to pray for forgiveness but his reply was always the same. 'Torment me no more, I am tormented enough already! I find nothing within me but blackness and darkness, brimstone and burning to the bottom of hell.' He roundly declared that he had sinned himself beyond all possibility of repentance, that he was already damned.

Certified as sane, the Weirs went on trial for their lives on 9 April 1670. The jury was unanimous in finding Grizel guilty of witchcraft, but it was a measure of the respect Major Weir still commanded that he was found guilty only by a majority vote. Grizel, who was charged with consulting witches, was sentenced to be hanged in the Grassmarket at the foot of the Castle Rock. Just as she was about to be executed, she tried to remove her clothes, so that she could die naked, 'with all the shame she could'.

On 11 April Thomas Weir was taken to be executed outside Edinburgh's city walls. He was permitted the mercy of strangulation before being burned. When the rope was tied around his neck, he was asked to say, 'Lord, be merciful to me!' but instead he shouted, 'Let me alone! I have lived as a beast and must die as a beast!' He died, as Sir Walter Scott later wrote, 'stupidly sullen and impenitent'. After his lifeless body dropped into the flames, his blackthorn staff carved with grinning satyrs heads was also thrown into the fire. It was chronicled by a contemporary writer: 'whatever incantation was in it, the persons present own that it gave rare turnings and was as long a-burning, as was himself'.

After their execution, stories spread rapidly about the Weirs and their home. Rumour spread that the street was haunted by phantoms and that Major Weir's ghost galloped down the street on a headless horse. On the anniversary of their deaths, it was reported that there were 'raucous sounds of merriment' coming from their house.

Sir Walter Scott wrote, 'Bold was the urchin who dared to approach the gloomy ruin of the West Bow house at the risk of seeing Major Weir's enchanted staff parading through the old apartments...'

Their house had such a fearsome reputation that it remained unoccupied for more than a century after their deaths. It was eventually leased cheaply to the Patullos,

Spectral activity is plentiful in Edinburgh. (© Gilly Pickup)

Are you one of them? (© Gilly Pickup)

an elderly couple, in 1773. Attracted by the low rent, they chose to disregard the spooky tales, though they only stayed one night as they encountered 'such unspeakable horrors' that they fled before daylight. The house remained empty until it was demolished in the 1800s.

Over the years, there have been numerous reported sightings of the major's ghost as well as that of a wraithlike Grizel, her body blackened by fire. There are those too, who claim to have heard the eerie sound of the major's infamous blackthorn staff as it taps its way across the cobblestones of the Grassmarket.

**And finally ... last of the Ghostly Snippets:** There is more chance of seeing a ghost between 1 a.m. and 3 a.m., as these are known as the 'hours of the dead'.

Spirits can often be protective of the families they haunt.

42 per cent of people claim to have experienced a supernatural encounter.

> *Yesterday, upon the stair, I met a man who wasn't there, He wasn't there again today. I wish that man would go away ...* (Anon)